GHOSTS OF THE
USS YORKTOWN

GHOSTS OF THE
USS *YORKTOWN*

THE PHANTOMS OF PATRIOTS POINT

BRUCE ORR
PHOTOGRAPHY BY KAYLA ORR

Haunted America

Published by Haunted America

A Division of The History Press

Charleston, SC 29403

www.historypress.net

First published 2012

Manufactured in the United States

ISBN 978.1.60949.781.1

Library of Congress CIP data applied for.

Greater love has no man than this, than a man lay down his life for his friends.
John 15:13—American King James Version

In Memory of Scott Arrington,
Sailor, Surfer, Warrior, Friend
Killed by a careless driver

Although you and I never got to toast our two getting married and you will not hold the child that will make us both grandfathers, we all know you are with us always.

I know you loved surfing the sea as much as I love diving below its surface
And we love those children of ours equally

To all those who made the ultimate sacrifice
Serving our country and protecting our freedom

CONTENTS

CONTENTS

PREFACE

RESPECT, HONOR AND HISTORIC PRESERVATION

After researching and writing my first book, *Six Miles to Charleston*, I discovered that, at times, the history behind hauntings can be far more intriguing than the legends themselves. I also realized that many of the stories that I grew up with were not preserved in written form and risked disappearing and being lost to future generations. Because of this, I formed a company, Lost in Legend, with the intent of preserving the folklore and legends of my community and state. I approached the subject in a manner in which I preserved the folklore yet incorporated the actual history behind the legend into the story. Thus our motto "Never let the facts get lost in the legend" was drafted. We focus on the history behind the haunting. I have done that with all my works, and this book will be no different.

During its existence, Lost and Legend has grown to include not only the preservation of our folklore, legends and ghost tales, but it has also included the historic conservation of our artifacts, buildings and legacies.

I have a deep respect for history and a deeper respect for our military and all those who made the ultimate sacrifice for the freedoms we take for granted. To have developed the reputation of being able to weave historic fact with ghost tales in a dignified manner is something that I

have worked hard at staying true to. To have that recognized and being entrusted to do so with such monuments to military and maritime history such as the USS *Yorktown* is an honor.

I am a retired law enforcement investigator. Investigations have always been something I loved. Many years ago, as a young patrol officer I was ecstatic to have been selected to become a detective in my agency's Criminal Investigative Division (CID). My supervisor, Senior Sergeant Hubert "Buddy" Lloyd, was the first to congratulate me, and I still have the handwritten note that he posted in the South District Squad Room for all to see. He recognized that being selected to CID was a turning point in my career, and he made sure that he was the very first to congratulate me.

Buddy Lloyd was a man who had taken an interest in me not only as a young officer, but also as a friend. He realized that I was a struggling young father trying to make ends meet. He also realized that for that very reason that young man was missing meals at work to pay the bills at home. He often traded a barbecue sandwich for assistance in administrative work or a hamburger for a detailed wash job on his cruiser after my shift was over.

Two years after transferring to the Criminal Investigative Division, I was leaving one afternoon and ran into Buddy Lloyd in the parking lot. He had since been placed over the aviation unit, and as he approached, I could see his flight suit was stretched rather tightly across his midsection. I approached him and slapped him on his round belly, stating, "You had better lose some weight before your fat ass crashes and burns in that 'copter, old man." He laughed at me and told me I was not in the best shape myself. I got into my unmarked car and drove away to a much-needed vacation, not realizing that those were the last words I would ever say to my friend.

A few days into my vacation, I received a phone call in Indiana and was advised that the agency's helicopter had gone missing while on a mission searching for the Lowcountry serial rapist. The elusive rapist had terrorized the area for a number of years and was responsible for approximately thirty sexual assaults on women throughout Berkeley, Dorchester and Charleston Counties. Now it seemed that he was inadvertently responsible for the disappearance of two of my friends.

I immediately returned from my vacation and joined my friend Rick Presnell and over three hundred others in a search-and-rescue operation for Buddy and his spotter, Bill Nalley. It was believed that the black helicopter had gone down in the dense woods adjacent to the airport and that the two on board may possibly be injured and still alive. Four days later, we located the wreckage and our hopes of a rescue turned into a recovery operation as Senior Sergeant Buddy Lloyd's and Deputy Bill Nalley's remains were removed from the woods.

Ironically, Buddy had died in the manner in which I had kidded him about. The investigation revealed that the helicopter had been overweight, and Buddy had attempted to return to the airport. Due to poor visibility, it had clipped the top of one of the trees, spun out of control and was destroyed in a fiery crash. On June 7, 1992, twenty years ago to the date that I am writing this, Buddy and Bill became part of Lowcountry history when they died in the line of duty searching for a serial rapist. That man, Duncan Proctor, was later captured and is serving two consecutive life sentences for his crimes. My friends paid the ultimate price in a mission they were dedicated to. When over three hundred of us united in our search, we were dedicated to our mission also. We were determined to bring them home, and we did.

I have told that story because I am often asked about the engraved aluminum blue band that I wear around my wrist. It is a memorial band that honors a supervisor who fed his young subordinate barbecue sandwiches because he knew he did not have the money to feed himself while putting food on the table for his family. He also knew the young man had too much pride to accept a handout, and out of respect, he found a way to make him work for it.

I know about respect. Buddy Lloyd was one of many who taught me its formula: it must be given in order to be earned. I also know about honor. It comes when one has learned the formula for respect.

As I left a planning meeting for this project, my elevator opened onto the Hangar Deck aboard the USS *Yorktown*. I have always had a fascination with World War II aircraft, and for reasons unknown, I have always been drawn to the F4U *Corsair*. As I was walking past her aircraft, I heard a familiar sound. It is a sound that I have never gotten used to and

one that I have heard far too many times. It is a sound I heard many years ago as I stood at attention in full uniform in a cemetery as two helicopters flew over in honor of two of my fallen brothers.

Taps began to play.

It was an emotional moment for me inside that hangar and drove home exactly how much of an honor writing this book truly is.

ACKNOWLEDGEMENTS

I would like to thank the following people and organizations:

Adam Ferrell, publishing director at The History Press, for the concept of this book.

Mac Burdette, executive director of Patriots Point Naval and Maritime Museum.

David A. Clark, senior curator and director of exhibits for Patriots Point Naval and Maritime Museum.

Sis Reda, director of marketing and sales for Patriots Point Naval and Maritime Museum.

Ashley Smith, public information officer for Patriots Point Naval and Maritime Museum.

Rick Presnell, owner of Swamp Fox Diving.

Tom and Sally Robinson, owners of Charleston Scuba.

Charles "Charlie" Fox.

The Charleston County Rescue Squad.

Edgar "Sonny" Walker, president of USS *Laffey* Association.

Brian Parsons, chief electrician at Patriots Point.

A.J. Tarquino, USS *Laffey* Association webmaster.

Christina Wood Jordan, of Corporate Events and Catered Affairs.

Lori Von Dohlen, of Corporate Events and Catered Affairs.
Boy Scouts of America, Coastal Carolina Council.
Bruce M. Frey, Patriots Point volunteer.
Robert "Skip" Moore.
Pilot V.T. "Tony" Whitlock and Wendi Slemmer, Pee Dee Helicopters.
Susan Fowler, the Official Shadow People Archive.
The staff at the Berkeley County Public Library.
The staff at the Charleston County Public Library.
The staff at the Dorchester County Public Library.
Kayla Orr, KOP Photography.
Joe Venezia, Patriots Point volunteer.
Vernon Brown, Patriots Point volunteer.

INTRODUCTION

South Carolina's history has never stopped at her shoreline. In fact, the waters surrounding the Lowcountry contain as much, if not more, history than do her cities, towns and villages. It was by travel on these waters that Charlestowne was discovered in 1670. It was also by continued travel on these waters that the town was sustained and goods were imported and exported.

The commercial import and export of goods attracted many seafaring folk, but not all of those people that traveled these waters had the greatest intentions. Pirates found their way into our harbor to prey on others bringing goods. Piracy interfered with commerce. This created problems, and soon solutions to those problems were created. Ships began to patrol these waters, and as the pirates were captured, a more permanent solution to piracy was introduced at the end of a rope.

Eventually, forts occupied by the military forces that protected this land began to fill the harbor in an effort to protect her waters. Those forces defended our seas and our shores from ALL enemies, both foreign and domestic. Eventually, those enemies would also include ourselves when South Carolina chose to secede from the Union and the Confederacy fired the first shots of the Civil War, shots that were fired over these waters and into Fort Sumter.

No, the history of the Lowcountry definitely does not stop at her shoreline, but the sea is a lot slower in giving up her secrets than her earthy counterpart.

One such example occurred on February 17, 1864, as eight men traveled out into the Charleston Harbor on a secret mission. Thirteen others had already lost their lives to the waters in this very vessel, and by the end of this night's attack, these eight brave souls would also come to rest on the bottom of the harbor. It would not be until August 8, 2000, that the waters of the harbor would give up those dead. Even now, 12 years after releasing Lieutenant George E. Dixon and his crew, the sea has still not given up her secrets as to what happened to the CSS *Hunley* and her crew some 148 years ago.

Perhaps the fact that the Charleston Harbor is so adept at keeping secrets is the reason that these great ships—I refer to them as the "ghosts of war"—have chosen to reside here at Patriots Point. It seems that the sea and the ships have a mutual understanding of each other. Both these waters and these great ships are excellent at keeping their secrets and are notorious for creating mysteries.

The great Greek philosopher Plato is quoted as having said, "Only the dead have seen the end of war." If the stories of paranormal encounters at Patriots Point are true, then Plato is greatly mistaken. Perhaps for some dead the war never ends. Maybe they are caught in some perpetual cycle that never ceases. Quite possibly these dead are actually some paranormal echo that continues long after the initial event of their demise has ceased. Whatever they may be, there are some, because of their experiences, that believe these entities continue to walk the corridors of the USS *Yorktown* and fight in battles long ended.

When I was approached about working on a project about Patriots Point's paranormal experiences, I was honored yet cautious. The issues at the location have become so numerous and frequent that they could no longer be ignored. There became a necessity to document those events and a desire to share them with others, and I was presented with that opportunity. As I approached this endeavor, I wanted to investigate, interview and document those who have witnessed paranormal events at the maritime museum, but I wanted to do so in such a manner as

to respect those who gave their lives defending the freedoms so many take for granted. Indeed, caution should be exercised when dealing with such an intangible topic as "ghosts" and relating it to such tangible and historic locations as the USS *Yorktown*.

I grew up in the Charleston area as a navy brat. Both my father and my stepfather served in the United States Navy. Both were submariners. Both were chiefs, and both were radiomen. I guess when my mother found a good thing, she stuck with it. No one could ever say that the woman was not consistent.

My stepfather served on many subs, and he has helped me with this project. Although he never served on the USS *Clamagore*, he did serve on her twin sister, the USS *Tiru*. He was instrumental, and his experiences were invaluable, in helping me understand the mindset of the men living under extreme pressure—inside and out—of a submerged United States Navy vessel.

My father also served on many subs before a vehicle accident with a drunken driver injured his knees so badly that he could no longer negotiate the ladders. His injuries forced him to retire from a career he truly loved. One of the subs he served on was the USS *James Madison*. My father took pride in the fact that he took the first voyage out on the USS *James Madison* and, decades later, returned to take the last voyage back when she was decommissioned. He considered it one of his greatest accomplishments. He was a plank owner, a member of the original crew when the sub was commissioned, and had such a great love for her that he was honored to return to her when the opportunity arose. Perhaps the men on board the USS *Yorktown* at Patriots Point felt the same in death about their respective ship as my father did in life about his. Maybe that is why they return or maybe why they have never truly left.

Both my father and stepfather loved those old subs and spent a majority of their lives aboard them. They also logged plenty of hours in the "freckle maker" and yet emerged unscathed. It is my hope that, unlike a mischievous gremlin in the freckle maker, this book does not send a lot of highly pressurized waste material your way.

(To the uneducated, the freckle maker will be explained in a later chapter).

It is my intention to honor both of these men, my two fathers, and all others that served by honoring all those who may continue to serve on the ships at Patriots Point in battles long ended.

It has never been and it is still not my intention to persuade or dissuade you in the possibility of ghosts. That is a personal decision, and each person is entitled to their own belief. Each story within this book is based on an experience by those who are entitled to their belief based on their own personal encounter.

That having been said, my being an investigator, researcher and author of the topics I choose, many folks inevitably ask me my opinion in regard to the paranormal and the existence of ghosts. My answer to that is quite simple.

"That's complicated," is my response.

If the person or persons posing that question smile and regard my answer as evasive, then I let them go with a chuckle. If they persist, they invite themselves for the lecture that you the reader are about to receive.

The word paranormal does not equal ghost. Paranormal is something beyond reasonable explanation or our ability to explain as normal. It does not mean that it is unnatural. It is simply something that naturally occurs that we are not yet able to explain in an accepted scientific manner. There are things occurring every second that modern science has yet to explain. If you think everything in the realm of the human experience can be scientifically explained, then you are deluded. Even the things that we take for granted as scientifically acceptable are subject to reevaluation and change as time advances. What we accept now may be laughed at as ridiculous in the next century. Here is a case in point, as explained by J. Allan Danelek in his book *The Case for Ghosts: An Objective Look at the Paranormal*. I consider this one of the most compelling views in the field.

In the nineteenth century, it was accepted that illness and disease was caused by poisoned blood. The impurities had to be removed, so the medical professionals of that time did so by extracting the contaminated blood. This was accomplished in various manners. The simplest would be cutting the person and letting the blood flow. A more ingenious method was to attach leeches and have the disgusting vermin suck the blood out of you. Being an outdoorsman, fisherman and scuba diver, I can assure you

these are not cute, pleasant and cuddly little creatures to encounter. Quite frankly, I consider them to be slimy little vampires from the fiery pits of hell.

In 1799, the father of our country, George Washington, developed pneumonia after suffering a bout of laryngitis. As he lay ill, the finest doctors were brought in to help him. Their solution was to purge the former first president of his poisoned blood. In fact, up to a pint of the man's blood would be removed several times daily. Despite their best efforts, the former president died.

In the mid-nineteenth century, one scientist challenged everything that medical science believed in. The chemist stated that illness and disease were not caused be poisoned blood. He stated that they were caused by organisms that were invisible to the naked eye. He called these organisms "germs." He also went on to say that the process of bleeding a sick patient was actually detrimental to the person's health and did far more harm than good. He said that by removing the blood, the physicians were actually weakening the patient and depleting the body's natural ability in fighting off the disease. He further went on to say that many of the doctors' procedures were inadvertently killing their patients. As you might imagine, that did not go over extremely well in the medical community. As a general rule, physicians are not particularly overjoyed to be accused of harming—much less killing—patients they are trying to cure.

He was labeled a heretic. The man saw his hypothesis rejected as lunacy and nonsense by the established medical community. His invisible "germs" were labeled as ghosts and discounted. If one cannot see these creatures, then how can one possibly prove they exist? Still he persevered and eventually created a number of experiments to prove he was correct on all accounts. Eventually, an instrument was created that was able to magnify the chemist's "ghosts" to the point where the human eye could see them. That man, Louis Pasteur, was eventually vindicated by those experiments.

Today, Louis Pasteur's contributions, such as immunization and pasteurization, are taken for granted. The fact that this man, considered to be one of the founders of microbiology, has saved *millions* is readily accepted. The idea of bleeding someone with leeches causes one to shake their head and laugh at the sheer ignorance and lunacy of nineteenth-century science.

With the invention of the microscope, Pasteur's little "ghosts" were actually proven to exist. Perhaps those who laugh at and ridicule those who crawl around in haunted places will be proven wrong in the next century. Perhaps there is a Pasteur among them who will prove the existence of another type of ghost, one that is the remnant of a once living human being.

Many people laugh at the paranormal researcher chasing ghosts with instruments designed for other purposes. As one such investigator put it, in early days people used stones tied to sticks to chop notches in logs to build houses. Nowadays, builders use power saws and pneumatic nail guns specifically designed for that purpose. Paranormal investigators simply use what they have at hand until something better is created for the sole purpose of proving the existence of ghosts.

Having said all of that, I still remain skeptical yet open to the possibility of the existence of ghosts. The reason is that I was trained and have always been an investigator dealing with absolutes and not possibilities; after all, a person is convicted beyond a shadow of a doubt. Ghosts leave a lot of room for interpretation.

As a detective, I was responsible for undertaking an investigation and presenting the best case that I had. I did that by researching the incident, reviewing the scene, interviewing the witnesses and documenting the facts. On the other hand, Rick Presnell was a crime scene technician, and he was responsible for the collection, preservation, analysis and interpretation of all evidence at a scene. We then take those two investigative approaches and combine them to make the best case possible for presentation to a judge and jury. It is a system that all investigations should adhere to, be it a homicide investigation or a paranormal investigation. When you step outside your level of training and expertise, then you invite trouble. That is how many investigators lose cases. That is how all paranormal investigators lose credibility. They play both judge and jury.

As the author of this book, I will present you with the history, the hauntings and the heritage behind the USS *Yorktown* (CV-10) at Patriots Point Naval and Maritime Museum. It is my intention to do so in a manner that treats her dead with respect and to honor them and their ultimate sacrifice, not exploit them.

THE HISTORY

OWN A NAME OF HONOR

T he USS *Yorktown* (CV-10) is the second United States aircraft carrier to bear the name. She is the fourth of five United States ships to bear the name, a name that was taken from the Revolutionary War battle, the Battle of Yorktown. In order for one to appreciate the "Fighting Lady," one must first understand the lineage of which she descends and the history that precedes her.

THE BATTLE OF YORKTOWN: 1781

The Battle of Yorktown was a decisive victory in the American Revolutionary War. It was a combined assault of American forces led by General George Washington and French forces led by Comte de Rochambeau against the British Army commanded by Lieutenant General Lord Cornwallis. It proved to be the last major land battle of the American Revolutionary War in North America. The surrender of Cornwallis's troops prompted the British government to negotiate an end to the conflict.

In 1780, 5,500 French soldiers landed in Rhode Island to assist the American forces. Washington, after having received communications from

USS *Yorktown* (CV-10) is one of several ships to bear the name taken from the site of the famous Revolutionary battle. *Courtesy of KOP.*

France, learned of the possibility of support from the French West Indies fleet of Comte de Grasse. Rochambeau and Washington decided to ask de Grasse for assistance in surrounding and capturing British occupied New York or, as another alternative, assistance in military operations against the Redcoats in Virginia. De Grasse informed them of his intent to sail to the Chesapeake Bay, Virginia, where Cornwallis had taken command. Cornwallis's movements in Virginia had been covertly monitored by a Continental army reconnaissance force led by the Marquis de Lafayette.

The French and American armies united north of New York City and began moving south toward Virginia. While en route, the Continental armies knew that they also were being monitored by British forces. Having this knowledge, they utilized it to their advantage to lead the British to believe a siege of New York was planned. Compte de Grasse sailed from the West Indies and arrived at the Chesapeake Bay at the end of August, bringing additional troops and providing a naval blockade of Yorktown.

The History

Prior to his arrival and while in Santo Domingo, de Grasse had met with Francisco Saavedra de Sangronis of Spain. De Grasse had planned to divide his fleet before traveling to the Chesapeake Bay and leave several of his warships in Santo Domingo in case they were needed to protect the French merchant fleet. Upon hearing this, Saavedra promised the assistance of the Spanish navy to protect the French merchant fleet. This allowed de Grasse to sail on with all of his warships.

In early September, Compte de Grasse defeated a British fleet that was en route to relieve Cornwallis at the Battle of the Chesapeake. As a result of this victory, de Grasse blocked any escape by sea for Cornwallis. By late September, Washington and Rochambeau arrived, and the army and naval forces completely surrounded Cornwallis.

The Americans and French soon mounted their first assault and began bombardment of the enemy. On October 14, 1781, with the British defense weakened, Washington sent two columns, one French and the other American, to attack the last of the remaining British outer defenses. With these defenses taken, the allies were able to finish their second assault. With American artillery moving closer, the bombardment of the British became more intense than ever. Just three days later, on October 17, 1781, Cornwallis asked to capitulate terms to surrender. After two days of negotiation, the surrender ceremony took place at the Moore House and farm, a place chosen by Cornwallis.

During the intense battle, civilian casualties were commonplace. In fact, a stray bullet had struck and killed Augustine Moore Jr. while he was working the family fields.

Also in the vicinity of the Moore House, a local merchant named John Turner came to watch the Continental forces shelling the British Army in Yorktown just days before they surrendered. He was grievously wounded by shrapnel as a result of the shelling and, according to legend, died in his wife's arms. There was nothing she could do to save him. John Turner's remains were buried in the Moore House family graveyard.

The little farmhouse that had inadvertently become engulfed in the battle had now become the site of the surrender of the forces that had brought death to its doorstep.

Cornwallis refused to meet with Washington and also refused to come to the ceremony of surrender. He claimed to be ill, but more than likely, his pride and arrogance would not allow him to attend. Instead, he sent Brigadier General Charles O'Hara. O'Hara was to present the sword of surrender to Rochambeau, but Rochambeau refused it. He shook his head indicating no and then pointed to Washington. O'Hara offered it to Washington, but he also refused to accept it and motioned to his second in command, Benjamin Lincoln.

Benjamin Lincoln had been humiliated by the British at Charleston, and it was an opportunity for some payback to the British for that action. At Yorktown, the arrogant British had asked for the traditional honors of war. This consisted of marching out with their dignity, their British flags waving, their weapons shouldered and playing an American tune as a tribute to the victors. Washington reminded them that when the British had seized Charleston earlier in the war, they had refused the Americans, under Benjamin Lincoln, the same privilege. With that, Washington adamantly denied their request.

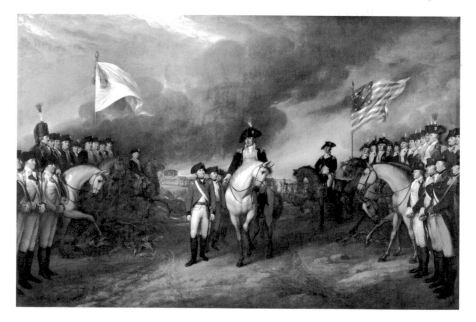

Surrender of Lord Cornwallis by John Trumbull.

Consequently, the British troops marched forward before Benjamin Lincoln with flags furled and muskets reversed in shame. They laid down their arms in between the French and American armies.

According to record, the French casualties were 60 killed and 194 wounded, and the American casualties were 28 killed and 107 wounded. The British suffered a far greater loss, with 156 killed, 326 wounded and 70 missing. Cornwallis surrendered 7,087 officers and enlisted men in Yorktown and 840 sailors from the British fleet in the York River. Another 84 prisoners had been taken during the assault on the British defenses on October 16. Since only 70 men were reported as missing, this would suggest that 14 of the men officially marked down as "killed" had, in fact, been captured. This gives a total of 142 killed, 326 wounded prisoners and 7,685 others taken as prisoners by the combined Continental armies. An additional 214 artillery pieces, thousands of muskets, twenty-four transport ships and numerous wagons and horses were captured. With this decisive victory, Great Britain began negotiations with the United States, which resulted in the Treaty of Paris in 1783.

Ironically, the USS *Yorktown* (CV-10) is not the only haunted Yorktown Museum. Apparently her namesake's museum is also. Paranormal manifestations of what are believed to be the spirits of Augustine Moore Jr., John Turner and John Turner's wife started making their appearances after the Park Service fully restored the Moore House Museum to its eighteenth-century decor.

In the parlor, there has been a depression in a red velvet chair, as if someone was sitting there. Sheets on the bed in the master bedroom have been found with indentations, as if someone had been sleeping in the bed, and sheets on the beds in the bedrooms on the second floor also look as if someone had slept in them.

Tour guides showing groups around the home have felt that they were being accompanied by an unseen, friendly presence overseeing their tour, much like the Patriots Point staff experience.

THE FIRST USS *YORKTOWN*: 1839

The first ship to carry the name *Yorktown* for the United States Navy was a sixteen-gun sloop-of war. Her primary duty was patrolling the Pacific and also confronting the slave trade industry in Africa's waters. She was first launched in 1839, and as she patrolled the Pacific, her mission was to protect the United States' interests in ocean commerce and also in the whaling industry.

In 1844, she patrolled the west coast of Africa in an effort to enforce the Act Prohibiting Importation of Slaves of 1807. This law was enacted by Congress on March 2, 1807. The new United States federal law banned new slaves from being collected and imported into the United States. It took effect in 1808, the earliest date permitted by the Constitution of the United States, adopted twenty years earlier in 1787. The United States Constitution had prevented Congress from interfering or regulating the importation of slaves until that date.

As the date for enacting the law approached, many states increased their efforts in the slave trade. When the date finally arrived, the act made illegal the U.S.-based transatlantic slave trade, even though smuggling continued long afterward. Slavery, unfortunately, continued in the United States until the end of the Civil War. Once the Thirteenth Amendment to the Constitution was adopted, the act of slavery was abolished, but that was many, many years away. Until then, it was the duty of the original USS *Yorktown* to enforce the 1807 act prohibiting collection and importation.

USS *Yorktown* ranged up and down the west coast of Africa. Her patrols went as far south as Cape Town and Cape Colony, as she attempted to curtail the slave trade. In the course of her patrols, the sloop captured three slave ships—the *Pons*, *Panther* and *Patuxen*.

On September 6, 1850, she struck an uncharted reef about a mile off the northern coast of Maio Island in the Cape Verde Islands. Once stranded, the ship broke up in a very short amount of time, but not a single life was lost in the wreck.

The crew of USS *Yorktown* evacuated to Maio Island and lived there for a little over a month. The crew did little more than relax. The most

energy they expended was racing donkeys. The donkeys ran wild on Maio Island, and the crew would entertain themselves by capturing them and holding the races. In fact, this activity continues on the island even today.

On October 8, 1850, the USS *Dale* arrived to pick up the crew, and they were transferred to the USS *Portsmouth*, which sailed for Norfolk, arriving in December 1850.

USS *YORKTOWN* (PG-1)

The second ship to bear the name *Yorktown* was a steel-hulled gunboat. She was the lead ship of her class and helped usher in the new era of steel-hulled ships within the United States. She was launched in 1888.

In 1899, she took part in the Philippine–American War, and in the following year, she was involved in the Boxer Rebellion. After three years out of commission from 1903 to 1906, USS *Yorktown* (PG-1) hosted the secretary of the navy on board when he greeted the Great White Fleet on its arrival in San Francisco in May 1907. The Great White Fleet was a nickname given to the U.S. fleet at this time, due to its hulls being painted white. Over the next five years, most of USS *Yorktown* (PG-1)'s time was spent in patrols in Alaska and duty in Latin American ports.

Through World War I, USS *Yorktown* (PG-1) continued in the same role, until she departed for the East Coast of the United States in April 1918. She served as an escort for one convoy headed to Halifax in August 1918 and remained in coastal escort duties in the east until January 1919. After arrival at San Diego, California, a month later, she never left. She was decommissioned in June 1919, and she was sold in 1921 and broken up in Oakland sometime later that year.

USS *YORKTOWN* (CV-5)

The first United States aircraft carrier to bear the name *Yorktown* was commissioned in 1937. She quickly proved her worth in military maneuvers and also in neutrality patrols prior to the United States formally entering World War II.

On April 20, 1941, she departed Pearl Harbor in the company of the destroyers USS *Warrington* (DD-383), USS *Somers* (DD-381) and USS *Jouett* (DD-396). From that moment until the United States entered World War II, she conducted four Atlantic patrols and logged some 17,642 miles while enforcing America's neutrality.

At this point, America had remained neutral in the conflict, and Germany's leader, Adolf Hitler, had forbidden his submarines, known as U-boats, to attack American ships. American naval vessels patrolling the Atlantic, unaware of this policy, still remained alert and cautious.

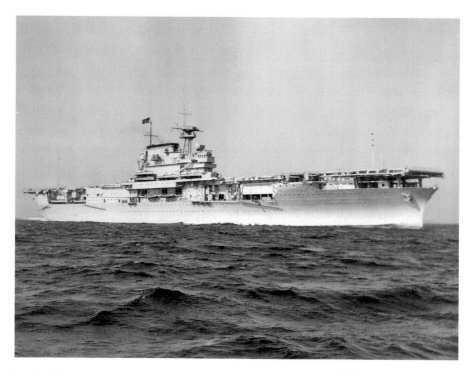

USS *Yorktown* (CV-5).

The History

On October 28, 1941, while the USS *Yorktown* (CV-5), the battleship USS *New Mexico* (BB-40) and other American warships were performing screening maneuvers for a convoy, an American destroyer picked up a submarine contact. Depth charges were dropped in an effort to destroy the U-boat while the convoy made an emergency turn. For the moment, the convoy seemed to have avoided danger, but that afternoon, engine repairs to one of the ships, the *Empire Pintail*, greatly reduced the convoy's speed.

That night, the ships again intercepted strong and clear radio signals indicating that German U-boats were in the vicinity. The commander of the escort force, Rear Admiral H. Kent Hewitt, sent a destroyer to sweep behind the convoy to locate, depth charge and destroy the U-boat.

The next day, October 29, with scout planes patrolling overhead, USS *Yorktown* (CV-5) and USS *Savannah* (CL-42) fueled their escorting destroyers. On October 30, USS *Yorktown* (CV-5) was preparing to fuel three destroyers when other escorts detected sound contacts indicating they were being monitored by an enemy U-boat. In response, the convoy made ten emergency turns. While the USS *Hughes* (DD-410) assisted in developing the contact, USS *Morris* (DD-417) and USS *Anderson* (DD-411) dropped depth charges with no success in locating the enemy submarine. The USS *Anderson* again made two additional depth charge attacks after which they observed a considerable oil slick, but no wreckage.

Elsewhere on that very same day, the USS *Reuben James* (DD-245) became the first American warship lost to hostile enemy action during World War II. The German submarine *U-552* violated Hitler's supposed orders and torpedoed the destroyer, sinking her with heavy casualties. Of the 159 man crew, only 44 survived. This occurred almost two months before the Japanese attacked Pearl Harbor, forcing the United States to enter the war.

After having conducted another Neutrality Patrol in November, the USS *Yorktown* (CV-5) fortunately put into port at Norfolk on December 2, 1941. She was fortunate because she was there five days later on December 7, 1941, when the Japanese did attack Pearl Harbor, decimating the majority of the U.S. Navy's Pacific Fleet.

Once the Japanese forces had inflicted heavy damage to the United States Navy at Pearl Harbor, the role of the aircraft carriers that remained took on new importance. USS *Yorktown* (CV-5) quickly left the Atlantic and sped toward the Pacific Ocean to join what was left of the nearly decimated Pacific Fleet. She soon became the flagship for Rear Admiral Frank Jack Fletcher's newly formed Task Force 17 (TF17).

On May 6, 1942, she engaged in her first confrontation with the Japanese during the Battle of the Coral Sea. The carrier seemed almost invincible as she managed to dodge eight torpedoes. After that initial attack, she was then attacked by Japanese dive bombers. The ship again miraculously managed to evade all the bombs…except one. Her invincibility ended when that one bomb hit its mark. The bomb penetrated the Flight Deck and exploded below decks, killing several and seriously injuring many more.

Though the *Yorktown* was damaged, there was little time for repairs. Allied intelligence had decoded Japanese naval messages and determined that the Japanese were about to begin a major operation aimed at two islets in a low coral atoll. This location was known as Midway.

Having obtained this intelligence, Admiral Nimitz began planning for Midway's defense. He rushed all possible air and land reinforcement to Midway in anticipation of the attack. In addition, he began gathering his naval forces to meet and engage the enemy at sea.

On May 27, USS *Yorktown* (CV-5) arrived at Pearl Harbor after having received orders to briefly return there for repairs. Shipyard workers hastily made enough repairs to enable the ship to turn around and head back to Midway. In fact, the repairs were made in such a short time that the Japanese naval commanders had mistaken *Yorktown* for another vessel. They thought that she had been sunk after being damaged at the Battle of the Coral Sea and were greatly surprised that she had not been. Now with her air group augmented by planes and crews from USS *Saratoga* (CV-3), *Yorktown* returned and sailed as the core of TF17 on May 30.

USS *Yorktown* (CV-5), now flying Rear Admiral Fletcher's flag, rendezvoused with TF16 under Rear Admiral Raymond A. Spruance. She arrived northeast of Midway and maintained a position ten miles to the north.

Scout patrols, both land-based from Midway and ocean-based from the carriers, were flown during early June. At dawn on June 4, *Yorktown* launched a ten-plane group of Dauntlesses from group VB-5 to join in the patrols but found nothing.

Later, planes flying from Midway sighted the approaching Japanese and broadcast the alarm for the defending forces. Admiral Fletcher, the tactical commander, ordered Admiral Spruance's TF16 to locate and attack the approaching Japanese carrier force.

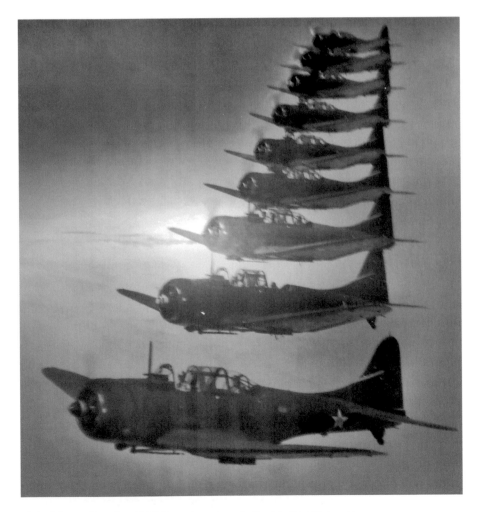

United States Douglass SBD Dauntless aircraft. *Patriots Point photograph.*

When the last of *Yorktown*'s search group returned at 0830 (8:30 a.m), the Flight Deck was immediately regrouped for the launch of the ship's fighter attack group.

The torpedo planes from the three American carriers—*Yorktown*, *Enterprise* and *Hornet*—located the Japanese force. Of the forty-one planes launched, only six returned to *Enterprise* and *Yorktown*. Not a single plane made it back to the *Hornet*.

Yorktown's dive bombers attacked the Japanese aircraft carrier *Sōryū*. Three lethal hits with one-thousand-pound bombs set her on fire. Meanwhile *Enterprise*'s planes attacked the Japanese aircraft carriers *Akagi* and *Kaga*, destroying both of them. Timing could not have been better. The attacking Dauntlesses had caught all of the Japanese carriers in the midst of refueling and rearming operations. Their bombs ignited the fuel and caused devastating fires and explosions.

Three of the four Japanese carriers had been destroyed. The fourth Japanese aircraft carrier, the *Hiryū*, separated from the others. She launched eighteen Japanese aircraft, which soon located *Yorktown*.

At approximately 1329 (1:29 p.m.), the attacking Japanese aircraft were detected by the *Yorktown*'s radar. In preparation for the attack, she immediately discontinued fueling her fighters, and her dive bombers were moved to open up the area for antiaircraft fire. An auxiliary eight-hundred-gallon gasoline tank was pushed overboard in an effort to eliminate one potential fire hazard. The crew quickly drained fuel lines to prevent additional fire hazards and closed and secured all compartments.

All of *Yorktown*'s fighters were sent out to intercept the Japanese aircraft. The Wildcats countered an organized attack by eighteen Japanese "Vals" and six Japanese "Zeroes." Despite their best efforts, three "Vals" scored hits prior to being destroyed. Two of them were able to drop their bombs prior to being shot down while the third lost control just as his bomb left the plane's rack. The enemy aircraft began tumbling in flight and hit on the starboard side, exploding on contact. The explosion of both bomb and aircraft blasted a hole about ten feet square in the Flight Deck. The exploding bomb killed most of the crews of the two 28-millimeter gun mounts it had struck and several others on the Flight Deck below. Other fragments penetrated the Flight Deck and struck three planes on

the Hangar Deck, starting fires. One of the burning aircraft, a *Yorktown* Dauntless, was fully fueled and still carrying a one-thousand-pound bomb. Swift action extinguished the fire and prevented what could have been a secondary deadly explosion.

The second Japanese bomb to hit the ship came from her port side. It also pierced the Flight Deck and exploded. This one did extensive damage to the ship's boilers. The explosion ruptured the uptakes for three boilers, disabled two boilers and extinguished the operating fires in five additional boilers. In addition, smoke and gases began filling the fire rooms of six boilers. Despite the danger, the crew at number one boiler remained at their post and kept it operating. This created enough steam pressure to allow the auxiliary steam systems to function.

A third bomb hit the carrier from the starboard side, pierced the side of number one elevator and exploded on the fourth deck. It started a fire adjacent to the forward gasoline stowage and magazines. The pre-attack preparation technique of smothering the gasoline system with carbon dioxide prevented the gasoline from igniting.

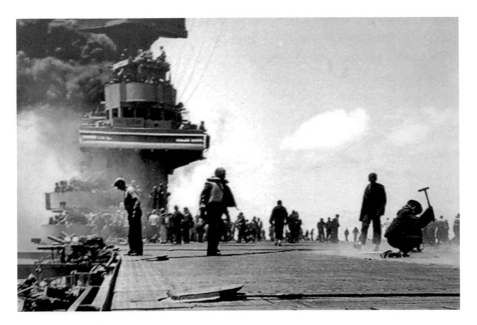

The Island Structure burns during the Battle of Midway.

Her speed dropped drastically. At 1440 (2:20 p.m.), about twenty minutes after the enemy bomb exploded, shutting down most of the boilers, USS *Yorktown* (CV-5) slowed to a complete stop.

Repair crews began working frantically, and at about 1540 (3:40 p.m.), *Yorktown* prepared to get moving again.

Simultaneously as *Yorktown* began refueling the fighters on the Flight Deck, the ship's radar picked up an incoming attack group at a distance of thirty-three miles. The ship once again prepared for battle as she had before. She also redirected four of the six fighters in the air to intercept the incoming Japanese aircraft. There were ten fighters on board, but eight had as little as twenty-three gallons of fuel in their tanks. Despite the limited fuel, they were launched and also headed out to intercept the rapidly approaching Japanese planes.

At 1600 (4:00 p.m.), USS *Yorktown* (CV-5) began gaining speed. The fighters that had originally been in flight and redirected by *Yorktown* intercepted the enemy. The Wildcats shot down at least three, but the rest made it past and began their attack while the carrier and her escorts mounted a heavy antiaircraft barrage.

Yorktown maneuvered radically, avoiding two torpedoes before another two struck the port side within minutes of each other. The attack left the carrier crippled and dying. She soon lost power and went dead in the water. She began to develop an increasing list to her port side. Her rudder was also jammed during the attack.

As the ship's list increased, Commander C.E. Aldrich, the damage control officer, reported that without power, controlling the flooding would be impossible. Likewise, the engineering officer, Lieutenant Commander J.F. Delaney, soon reported that all boilers were out, all power was lost and that it was impossible to correct the rapidly increasing list. Upon hearing these reports, Captain Elliot Buckmaster ordered Aldrich, Delaney and their men to evacuate to the Flight Deck and put on life jackets.

The list continued to increase. When it reached twenty-six degrees, Captain Buckmaster and Aldrich agreed that capsizing was moments away. "In order to save as many of the ship's company as possible..." the captain later wrote, he "ordered the ship to be abandoned."

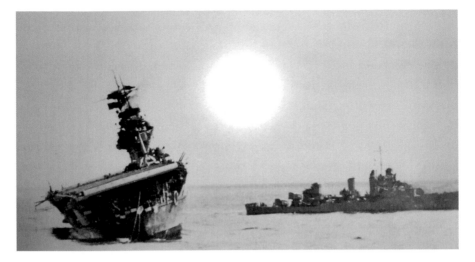

The USS *Yorktown* (CV-5)'s list intensifies.

Over the next few minutes, the crew lowered the wounded into life rafts and headed for the nearby Allied destroyers and cruisers. After the evacuation of the wounded, the executive officer, Commander I.D. Wiltsie, left the ship down a line on the starboard side. Captain Buckmaster, meanwhile, toured the ship one last time to see if any crew remained. After finding no "live personnel," Buckmaster lowered himself into the water by means of a line over the stern. By this time, water was crashing at the port side of the Hangar Deck of the listing carrier.

After being picked up by the destroyer USS *Hammann* (DD-412), Captain Buckmaster transferred to the USS *Astoria* (CA-34), where he reported to Rear Admiral Fletcher. After briefing Fletcher, the two men agreed that a salvage party should attempt to save the ship. *Yorktown* had surprised them all. She had not capsized and had remained afloat despite the heavy list.

While efforts to save the *Yorktown* were being made, her planes were still in action. They had joined those from USS *Enterprise* (CV-6) in striking the last Japanese carrier *Hiryū* and inflicting serious damage upon her. Having taken four direct hits, the Japanese carrier soon became totally helpless. Just like the *Yorktown*, she too was soon abandoned by her crew and left to drift out of control.

Yorktown continued to remain afloat through the night. Despite the earlier evacuation, two men were still alive onboard her. One of the two survivors attracted attention by firing a machine gun, which was heard by the destroyer USS *Hughes*. The escort picked up the two men. Unfortunately, one died soon after his rescue.

Meanwhile, Captain Buckmaster had selected 29 officers and 141 men to return to the ship in an attempt to save her. Five destroyers formed an antisubmarine screen while the salvage party boarded the badly damaged and listing carrier. The USS *Vireo* (AT-144) soon commenced towing the ship.

Yorktown's salvage party went on board with a carefully predetermined plan of action to be carried out by men from each of the ship's departments. Lieutenant Commander Arnold E. True brought his ship, the USS *Hammann* (DD-412), alongside, furnishing pumps and electric power in an effort to assist the salvage crew.

By mid-afternoon, it looked as if the attempt to save the ship was going to succeed. One 5-inch (127-mm) gun had been dropped over the side, and a second was being positioned to be likewise. Planes had also been pushed over the side. All of this was done in an effort to reduce top-side weight. The submersible pumps, powered by electricity provided by the *Hammann*, had actually been successful in pumping a lot of the water out of the engineering compartments. The efforts of the salvage crew were actually working, and they had reduced the carrier's list by about two degrees. It appeared as if the aircraft carrier might be saved.

While all this was transpiring, the Japanese submarine *I-168*, unknown to *Yorktown* and the six nearby destroyers, had achieved a favorable firing position and waited. At 1536 (3:36 p.m.), lookouts spotted four torpedoes approaching the ship from the starboard side.

Hammann went to general quarters and turned a twenty-millimeter gun in their direction to intercept the torpedoes in an attempt to explode them in the water. Her propellers also came to life and churned the water beneath her Fantail as she tried to get underway.

It was too late. One torpedo hit *Hammann* directly in the middle and broke her back. The destroyer folded like a jackknife and went down rapidly.

Two of the torpedoes struck *Yorktown*. The fourth torpedo passed just behind the carrier.

About a minute after *Hammann* sank, there was an enormous underwater explosion. This was possibly caused by the destroyer's depth charges going off beneath the ocean's surface. The blast killed many of *Hammann*'s men and a few of *Yorktown*'s who had been thrown into the water during the torpedo attack. The concussion battered the carrier's already badly damaged hull and caused tremendous shockwaves that resulted in even further damage to the ship.

All destroyers immediately commenced searches for the enemy submarine and commenced rescuing men from *Hammann* and *Yorktown*. Captain Buckmaster decided to discontinue any further salvage attempts until the following day.

Vireo cut the towline and doubled back to *Yorktown* to pick up survivors. She took on board many of the men of the salvage crew who had remained on the carrier while simultaneously picking up other men from the water. The tug took a tremendous beating as the sea battered it against the sinking carrier.

In the frenzy, the Japanese submarine, *I-668*, escaped.

Any additional attempts at salvage of USS *Yorktown* (CV-5) were never made. Throughout the night of June 6 and into the morning of June 7, the stubborn ship did her best to stay afloat in defiance of the mortal

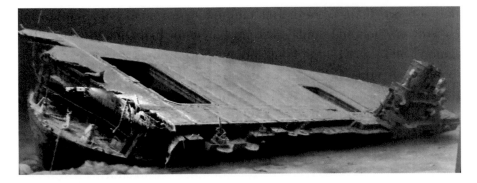

The USS *Yorktown* (CV-5) still rests on the ocean floor after the Battle of Midway. *Courtesy of Patriots Point.*

wounds inflicted upon her by the Japanese forces. By 0530 (5:30 a.m.), the crews of the ships nearby noted that the carrier's list was rapidly increasing to port. At 0701 (7:01 a.m.), the ship turned over onto her port side, rolled upside-down and sank, stern (rear) first, in three thousand fathoms of water, where she now remains over three miles below the surface.

USS *YORKTOWN* (CV-10)

Any efforts to list all of the achievements of the USS *Yorktown* (CV-10) are bound to come up lacking, but in order to explore the possibility of a paranormal aspect of her, one must first understand all that she faced and accomplished in her service. The following is an attempt to briefly cover her stellar naval career and the events she encountered prior to her arrival at Patriots Point.

USS *Yorktown* (CV-10) was initially intended to have received another name. She was to have been named the USS *Bon Homme Richard* in honor of Revolutionary War hero John Paul Jones's frigate. John Paul Jones was a Scottish sailor who became the United States' first well-known naval fighter after joining the Continental navy during the Revolutionary War. Jones is most famous for uttering the words, "I have not yet begun to fight" when taunted to surrender by the British captain of the HMS *Serapis*.

Jones had named his frigate in honor of Benjamin Franklin, who was the U.S. ambassador to France at the time. The name *Bon Homme Richard* is derived from the pen name of Benjamin Franklin who was, among many things, the author of *Poor Richard's Almanac*.

The aircraft carrier was renamed *Yorktown* while under construction to commemorate her predecessor, the USS *Yorktown* (CV-5), destroyed by the Japanese at the Battle of Midway in June 1942.

USS *Yorktown* (CV-10) was commissioned in April 1943, with Captain Joseph J. Clark in command. She would participate in several campaigns in the Pacific Theater of Operations and distinguish herself by earning eleven battle stars and the Presidential Unit Citation.

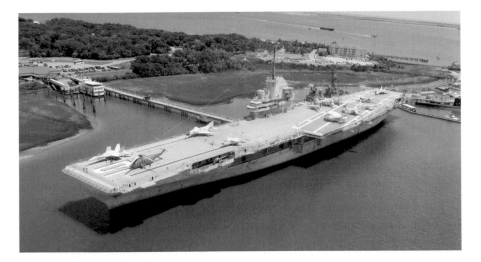

USS *Yorktown* (CV-10). *Courtesy of KOP.*

On August 22, she left out of Pearl Harbor, bound for her first combat of World War II, where she would play a significant role in the Pacific Offensive against Japan in late 1943. *Yorktown* (CV-10) was the tenth aircraft carrier to serve in the United States Navy, and the 888-foot ship displaced 27,100 tons during World War II and carried a crew of 380 officers, 3,088 enlisted men and ninety aircraft. As she departed, she also had a unique passenger onboard that Captain Joseph "Jocko" Clark would soon discover.

Not long after departure, Captain Clark found a small gray dog that some of the pilots had smuggled onto the ship. The dog was dressed in a life jacket and was barking on the Flight Deck. The captain responded to the discovery by stating, "There is a (expletive deleted) dog barking on the deck! What in the hell is going on here?" Although the dog's name was Scrappy, the pilots responded, "We call him Jock." Apparently the quick thinking worked, and the captain allowed the dog to stay. He became the ship's mascot.

An aircraft carrier such as the USS *Yorktown* is basically a floating city with over three thousand people living there. There are doctors' offices, dental offices and even stores just like any other city. The one thing it did not have was a park for Scrappy to relieve himself in. Scrappy

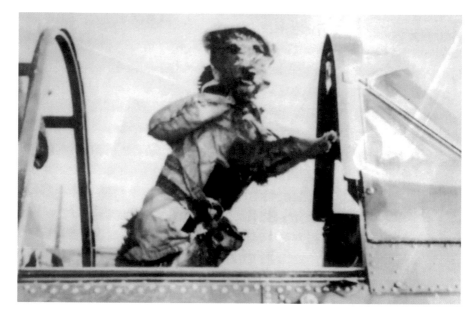

Scrappy, the ship's mascot, in the cockpit of one of the *Yorktown*'s aircraft. *Courtesy of Patriots Point.*

went wherever nature called...much to the displeasure of the *Yorktown*'s executive officer.

On the morning of August 31, the USS *Yorktown* (CV-10)'s task force, TF15, arrived at a launching point approximately 128 miles from Marcus Island. She spent most of that day launching strikes on Marcus Island before returning to Hawaii that evening.

On October 5, she began two days of air strikes on Japanese installations on Wake Island. She resumed those attacks early on the morning of October 6 and continued them through most of the day.

On November 10, she departed Pearl Harbor in company with Task Force 50, the Fast Carrier Task Force of the Pacific Fleet. She participated in her first major assault operation—the occupation of the Gilbert Islands.

On November 19, she arrived at the launch point near Jaluit and Mili Atoll and launched the first of a series of air attacks to suppress enemy airpower that was attacking the amphibious assaults on Tarawa, Abemama and Makin. By November 22, her air group concentrated on

installations and planes at Mili once again, and before returning to Pearl Harbor, the aircraft carrier made passing attacks on the installations at Wotje and Kwajalein Atolls.

On January 16, 1944, she participated in Operation Flintlock, supporting an amphibious assault during the Marshall Islands invasion. Her task group, Task Group 58.1, arrived at its launching point early on the morning of January 29, and its carriers, *Yorktown*, *Lexington* and *Cowpens*, began sending up air strikes for attacks on Taroa airfield, located on Maloelap Atoll.

When the amphibious troops stormed ashore on January 31, *Yorktown* pilots continued strikes on Kwajalein. On February 4, the task group retired to the fleet anchorage at Majuro Atoll, which had recently been secured from the enemy.

Over the next four months, USS *Yorktown* (CV-10) continued to participate in a series of successful air raids. After eight days at Majuro, she combined with her task group on February 12 to conduct additional highly successful air strikes on the Japanese at Truk Atoll. On February 22, she conducted a single day of raids on enemy airfields and installations on Saipan. On March 8, the carrier rendezvoused with the rest of TF 58. On March 30 and 31, she launched air strikes on Japanese installations located in the Palau Islands, and on April 1, her pilots attacked installations on the island of Woleai.

On April 12, she began launching raids in support of General Douglas MacArthur's assault on the Hollandia area. On April 22 and 23, they shifted to the landing areas at Hollandia themselves and began providing direct support for the assault troops. After those attacks, she left the New Guinea coast for another raid on Truk lagoon. *Yorktown* entered Majuro lagoon again on June 3 and began preparations for her next major amphibious support operation—the assault on the Marianas.

On June 6, the aircraft carrier left out of Majuro with Task Force 58 and set a course for the Mariana Islands. After five days, she reached the launch point and began sending planes in preparation for the invasion of Saipan. *Yorktown*'s aircrews concentrated primarily on airfields located on Guam. Those raids continued until June 13, when *Yorktown*, with two of the task groups of Task Force 58, moved north to hit targets in the Bonin

Islands. That movement resulted in a one-day raid on June 16 before the two task groups headed back to the Marianas to join in the Battle of the Philippine Sea.

On June 18, Task Force 58 reunited and waited for the approaching Japanese fleet and its aircraft.

On the morning of June 19, *Yorktown* aircraft began strikes on Japanese air bases on Guam. During the first day of the Battle of the Philippine Sea, *Yorktown* aircraft destroyed thirty-seven enemy planes and dropped twenty-one tons of bombs on the Guam air bases.

On the morning of June 20, USS *Yorktown* (CV-10) headed west with TF 58 while scout planes searched for the fleeing enemy task force. Contact was made, and *Yorktown* launched a forty-plane strike between 1623 (4:23 p.m.) and 1643 (4:43 p.m.). At about 1840 (6:40 p.m.), her planes found Japanese Admiral Ozawa's force and began a twenty-minute attack during which they went after the carrier *Zuikaku*. They succeeded in scoring some hits but failed to sink that carrier. They also attacked several other ships in the Japanese force.

On June 21, the carrier joined Task Force 58 in pursuing the enemy but gave up that evening when air searches failed to locate the Japanese. *Yorktown* returned to the Marianas area and resumed attacks on Pagan Island on June 22 and 23. On June 24, she launched another series of attacks on Iwo Jima. On June 25, she laid in a course for Eniwetok and arrived there two days later. On July 3 and 4, she conducted a series of attacks on Iwo Jima and Chichi Jima. On July 6, she resumed strikes in the Marianas and continued them for the next seventeen days. On July 23, she headed off to the west for a series of raids on Yap, Ulithi and the Palaus. She carried out those attacks on July 25 and arrived back in the Marianas on July 29.

On November 7, the aircraft carrier changed operational control to TG 38.1 and, for the next two weeks, launched attacks on targets in the Philippines in support of the Leyte invasion. She rendezvoused with the other carriers on December 13 and began launching attacks on the island of Luzon in preparation for the invasion of that island.

After surviving the attacks against the Japanese, Task Force 38 encountered a typhoon that, ironically, sank three destroyers:

Spence, *Hull* and *Monaghan*. *Yorktown* participated in rescue operations for the survivors.

On January 3, 1945, *Yorktown* participated in attacks on the island of Formosa and continued with various targets for the next week. On January 10, *Yorktown* and the rest of Task Force 38 entered the South China Sea to begin a series of raids on Japan's inner defenses. On January 12, Task Force 38 pilots racked up an exceptional score: forty-four enemy ships. On January 15, raids were launched on Formosa and Canton in China. *Yorktown* participated in a raid on Formosa on January 21 and another on Okinawa on January 22 before clearing the area for Ulithi.

On the morning of February 16, the carrier began launching strikes on the Tokyo area of Honshū. On February 17, she repeated those strikes before heading toward the Bonins. Her pilots bombed and strafed installations on Chichi Jima on February 18. The amphibious landings on Iwo Jima took place on February 19, and *Yorktown* aircraft began support missions over the island from February 20 through February 23. On February 25, she attacked airfields in the vicinity of Tokyo. On February 26, *Yorktown* air-crewmen conducted a single sweep of installations on Kyūshū.

On March 18, she began launching strikes on airfields on Kyūshū, Honshū and Shikoku. At about 0800 (8:00 a.m.), a twin-engine bomber attacked her from her port side. The ship opened fire almost immediately. The plane began to burn but continued its run, passing over USS *Yorktown*'s bow and splashing in the water on her starboard side. Just seven minutes later, another enemy aircraft tried a similar assault but also went down. That afternoon, three dive bombers launched attacks on the carrier. The first two failed in their attacks. The third succeeded and was able to bomb the signal bridge. The bomb passed through the first deck and exploded near the ship's hull. It punched two large holes through her side, killing five men and wounding another twenty-six. USS *Yorktown*'s antiaircraft gunners brought the aircraft down.

March consisted of several additional raids. On March 29, the carrier sent out two raids and one photographic reconnaissance mission over Kyūshū. That afternoon, at about 1410 (2:10 p.m.), a single enemy aircraft made an apparent Kamikaze attack on the *Yorktown*. The antiaircraft

guns brought her down, and the plane passed over the ship and crashed in the ocean port side.

On March 30, *Yorktown* and the other carriers of her task group began to concentrate solely on the island of Okinawa. For two days, they pounded the island. On April 1, the amphibious assault troops stormed ashore, and for the next six weeks, *Yorktown* sent her planes to the island to provide support for the troops. On April 7, when it was discovered that a Japanese task force and the Japanese battleship *Yamato* were traveling south for one last desperate offensive, *Yorktown* and the other carriers quickly launched strikes to attack the *Yamato*. Pilots made several torpedo hits on *Yamato* just before the battleship exploded and sank. At least three five-hundred-pound bombs also hit the cruiser *Yahagi* and helped to sink it.

On April 11, *Yorktown* came under air attack again. *Yorktown*'s antiaircraft gunners brought down the single plane. Sporadic air attacks continued until her May 11 departure from the Ryūkyūs, but *Yorktown* sustained no additional damage from the enemy aircraft. Out of the attacking planes, the *Yorktown* antiaircraft battery managed to down another.

On May 28, the carrier resumed air support missions over Okinawa. In June, she moved off with Task Force 38 to resume strikes on the Japanese homeland. On June 3, her aircraft made four different sweeps of airfields. The following day, she returned to Okinawa for a day of additional support missions before leaving the area to evade a typhoon. On June 6–7, she again resumed strikes on Okinawa. She sent her pilots back to the Kyūshū airfields and, on June 9, launched them on the first of two days of raids on Minami Daito Shima.

By July 10, she was off the coast of Japan launching air strikes on the Tokyo area of Honshū. On July 29–30, she shifted targets back to the Tokyo area before another typhoon took her out of action until the beginning of the first week in August. On August 8–9, the carrier launched her planes at northern Honshū and southern Hokkaido. On August 10, she sent them back to Tokyo.

On August 13, the USS *Yorktown* (CV-10) attacked Tokyo for the last time. Two days later, on August 15, Japan agreed to capitulate surrender.

From August 16–23, *Yorktown* and the other carriers of Task Force 58 remained in the waters to the east of Japan, awaiting instructions.

She began providing air cover for the occupying forces in Japan on August 25 and continued to do so until mid-September. After the formal surrender of the Japanese force that took place on board the battleship *Missouri* on September 2, 1945, the aircraft carrier began air-dropping supplies to Allied prisoners of war still living in their prison camps. On September 16, *Yorktown* entered Tokyo Bay with TG 38.1.

For her accomplishments against the Japanese forces, she received eleven battle stars and the Presidentil Unit Citation during World War II.

On January 9, 1947, *Yorktown* was placed out of commission and was berthed with the Bremerton Group, Pacific Reserve Fleet. USS *Yorktown* (CV-10) remained in reserve for almost five years. In June 1952, she was ordered reactivated, and work began on her at Puget Sound. On December 15, 1952, she was placed in commission, in reserve, at Bremerton. On February 20, 1953, *Yorktown* was placed in full commission as an attack carrier (CVA), with Captain William M. Nation in command. The aircraft carrier conducted normal operations along the West Coast through most of the summer of 1953. On August 11, she joined TF 77 in the Sea of Japan. The Korean War armistice had been signed two months earlier, and therefore the carrier participated in training operations and not combat missions. She served with TF 77 until February 18, 1954.

After a brief repair period at Hunters Point Naval Shipyard, *Yorktown* departed to serve as a production platform for the filming of the documentary film *Jet Carrier*, which was subsequently nominated for an Academy Award.

In January 1955, she was called upon to help cover the evacuation of Nationalist Chinese from the Tachen Islands located near the communist-controlled mainland. On March 21, 1955, she was placed in commission, and in reserve, at the Puget Sound Naval Shipyard where she was scheduled to receive extensive modifications. The most significant of these modifications was an angled Flight Deck, which was necessary to increase her jet aircraft launching capability. She completed her conversion by that fall and on October 14, 1955, was removed from reserve status and placed back in full commission.

In the 1950s, the *Yorktown*'s Flight Deck was angled to accommodate jets such as this. *Courtesy of KOP.*

After re-commissioning, the carrier resumed normal operations along the West Coast until mid-March 1956. On March 19, 1956, she departed from San Francisco Bay on her way to her third tour of duty with the Seventh Fleet since her reactivation three years earlier. The warship performed operations with the Seventh Fleet for the next five months, conducting operations in the Sea of Japan, the East China Sea and the South China Sea. She also made port at places such as Sasebo, Manila, Subic Bay and Buckner Bay at Okinawa. On September 7, the aircraft carrier departed out of Yokosuka. For the remainder of 1956 through March 1957, she continued to perform tours of duty and operations until April 25 when she joined TF 77 as part of a task force. Those operations lasted three months. On August 13, the warship departed Yokosuka, made a brief pause at Pearl Harbor and arrived in Alameda, California, on August 25, 1957.

On September 1, 1957, her home port was changed from Alameda to Long Beach, California, where she was reclassified as an antisubmarine warfare (ASW) aircraft carrier. She was given the

new U.S. Naval designation CVS-10. On September 23, she departed Alameda and, four days later, entered the Puget Sound Naval Shipyard for overhaul and for the new modifications necessary to transform her into an ASW carrier. Those repairs, overhauls and modifications kept her in the shipyard until the beginning of February 1958. After those modifications were completed, she arrived at the naval ammunition depot at Bangor, Washington. After departing Washington on February 7, she entered Long Beach five days later. For the next eight months, *Yorktown* conducted normal operations along the West Coast.

On November 1, 1958, she departed San Diego to return to the western Pacific. After a stop at Pearl Harbor from November 8–17, *Yorktown* continued her western voyage and arrived in Yokosuka on November 25. During that deployment, the newly modified aircraft carrier qualified for the Armed Forces Expeditionary Medal on three separate occasions. The first time came on December 31, 1958, and January 1, 1959, when she participated in an American show of strength. This was conducted in response to the communist Chinese shelling of the offshore islands Quemoy and Matsu. These islands were occupied and held by Nationalist Chinese forces.

During January 1959, she also joined a group of contingency forces off Vietnam. This was during internal disorders within Vietnam caused by communist guerrillas in the southern portion of that country. That month she earned the expeditionary medal for her service in the Taiwan Strait. The remainder of the deployment, except for another return visit to Vietnam's waters late in March, consisted of normal training evolutions and routine port visits. She concluded that tour of duty at San Diego on May 21, and the carrier resumed normal operations along the West Coast for the remainder of 1959.

In March, April, May and June 1960, *Yorktown* earned additional stars for her Armed Forces Expeditionary Medal for duty in Vietnamese waters. She returned to the West Coast late in the summer and, late in September, began a four-month overhaul at the Puget Sound Naval Shipyard.

Yorktown emerged from the shipyard in January 1961 and returned to Long Beach, where she conducted refresher training and then resumed

normal West Coast operations until late July. On July 29, the aircraft carrier departed Long Beach, and that tour of duty in the Far East consisted of a normal schedule of anti-air and antisubmarine warfare exercises, as well as the usual port visits. She concluded that deployment at Long Beach on March 2, 1962.

Throughout the summer and into the fall, normal West Coast operations occupied her time. On October 26, the carrier departed Long Beach and set a course for the Far East. During that deployment, she served as flagship for Carrier Division 19. She participated in several anti-submarine (ASW) and antiaircraft (AAW) exercises, and this also included the South East Asia Treaty Organization (SEATO) ASW exercise known as Operation Sea Serpent. SEATO was an international organization of defense created to stop the further spread of communism into Southeast Asia. The deployment lasted until June 6, 1963.

Yorktown arrived back in her home port on June 18 and resumed normal operations for the remainder of the year as well as most of 1964. On October 22, she again set out for a tour of duty with the Seventh Fleet. A period of operations in the Hawaiian Islands delayed her arrival in Japan until December 3.

Yorktown had her first real involvement in the Vietnam War in 1964 and 1965. In February, March and April, she conducted a series of special operations in the South China Sea in waters near Vietnam. She concluded her tour of duty in the Far East on May 7, 1965, when she departed Yokosuka to return to the United States. The carrier arrived in Long Beach on May 17.

After seven months of normal operations out of Long Beach, she got underway for the western Pacific again on January 5, 1966. For the remainder of her active career, *Yorktown*'s involvement in combat operations in Vietnam dominated her activities. She arrived in Yokosuka on February 17 and joined TF 77 at Yankee Station. Over the next five months, the aircraft carrier spent three extended tours of duty with TF 77 providing ASW and sea-air rescue services. She also participated in several ASW exercises, including the SEATO exercise, Operation Sea Imp. The warship concluded her last tour of duty on Yankee Station in

The Vietnam-era Naval Support exhibit at Patriots Point. *Courtesy of KOP.*

July. She resumed normal operations for the remainder of the year and during the first two months of 1967.

When *Yorktown* arrived back in Long Beach on July 5, she entered the Long Beach Naval Shipyard that same day for almost three months of repairs. She completed repairs on September 30 and resumed normal operations. Late in November and early in December 1968, she served as a production platform for the filming of another movie, *Tora! Tora! Tora!* This movie recreated the Japanese attack on Pearl Harbor. Also in December 1968, she served as one of the recovery ships for the Apollo 8 space deployment.

On January 2, 1969, after a two-week stop in Long Beach, she joined the U.S. Atlantic Fleet. On February 28, the aircraft carrier arrived in her new home port of Norfolk, Virginia. She conducted operations along the East Coast and in the West Indies until late summer. On September 2, *Yorktown* participated in the major fleet exercise Operation Peacekeeper. During the exercise, she provided ASW and Search and Rescue (SAR)

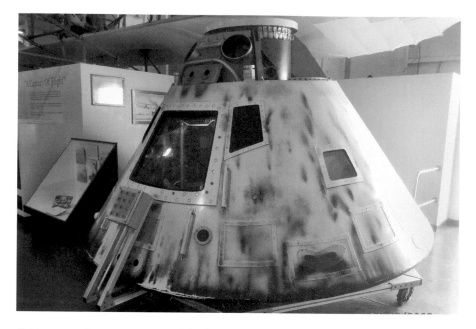

Yorktown served as a recovery vessel for the Apollo 8 astronauts. *Image Courtesy of KOP.*

support for the task force. The exercise ended on September 23, and *Yorktown* began a series of visits to northern European ports. After visiting ports at Brest, France and Rotterdam in the Netherlands, *Yorktown* departed for a series of hunter/killer ASW exercises from October 18 to November 11, after which she resumed her itinerary of port visits on November 11. She reentered Norfolk on December 11, 1969.

On June 27, 1970, she was decommissioned in Philadelphia and was berthed with the Philadelphia Group, Atlantic Reserve Fleet. She remained there almost three years before her name was finally struck from the navy on June 1, 1973.

The following year, the navy approved the donation of the USS *Yorktown* (CV-10) to the Patriots Point Development Authority in Charleston, South Carolina. In June 1975, she was towed to Charleston and formally dedicated as a memorial on the 200th anniversary of the United States Navy on October 13, 1975.

USS *Yorktown* (CV-10) was declared a National Historic Landmark in 1986.

USS *YORKTOWN* (CG-48)

Rounding out the list, the last ship to bear the name *Yorktown* was a Ticonderoga-class cruiser commissioned in 1984. This *Yorktown*'s first deployment was from August 1985 to April 1986 and, among other things, involved the *Achille Lauro* hijacker intercept, two Black Sea excursions and a trio of operations off the Libyan coast. As of late 2001, and since commissioning, *Yorktown* (CG-48) had completed five Mediterranean deployments. The cruiser was last home ported in Pascagoula, Mississippi. USS *Yorktown* (CG- 48) was decommissioned on December 3, 2004, and as of 2008, this incarnation of the *Yorktown* was scheduled to be dismantled.

II.

THE HAUNTINGS

AS IN LIFE SO ALSO IN DEATH:
A DEDICATION TO DUTY

For every exhibit there is a story; for some of them the past refuses to die.
—John Schuster from Haunting Museums

AN APPARITION IN KHAKI

Justin* (not his actual name) has been a scuba diver for over thirty years and has logged some three thousand dives in both a professional and recreational capacity. He holds several instructor certifications in the field and had served as both a diver and a supervisor of the Underwater Recovery Team (URT) prior to his retirement from law enforcement.

He is currently a diving instructor and certifies individuals in all aspects of diving, be it recreational, professional or technical. Justin will be the first to tell you that even with all the technical training and experience, things can go wrong. Every time a diver goes below the surface, that person is entering a hostile environment. Simply put, human beings are not designed to breathe underwater and therefore must rely upon scuba (Self Contained Underwater Breathing Apparatus) to sustain life until they return to the surface again.

All dive equipment must be maintained, properly cared for and serviced regularly. Even with that, a diver can experience issues with equipment. Even properly maintained equipment, although unlikely, can fail on rare occasions. There are also environmental factors that a diver has to contend with during each dive, which can vary from curious and inquisitive sea life to poor visibility and overhead environments. Divers must train with their equipment and do so in various conditions. A good diver will also know what his partner is using and how to assist in the appropriate use of that equipment in an emergency situation. The bottom line is that adequate training, being aware of your dive environment and conditions and knowing your equipment and your partner's minimizes the danger factor in diving.

Diving in the Charleston area is a challenging experience. The foremost issue is visibility. Many divers abandon this state and travel to the crystal clear springs of Florida, where visibility is unlimited and the water temperature is seventy-two degrees year-round. There are others

The author and others participating in a simulated diver rescue. When inexperienced divers exceed their level of training, a rescue may quickly turn into a recovery operation. *Courtesy of Lost in Legend.*

The author holding a Megalodon tooth recovered from local waters. *Courtesy of Swamp Fox Diving.*

who accept the challenges this state has to offer, and they travel from other areas to this state to dive the murky waters of the Cooper River, where visibility is—at best—three feet. Generally, it can be less than that. One may ask why a person would want to travel to dive in an environment with the consistency and visibility of an oatmeal bath. The answer is quite simple.

Megalodon teeth.

The megalodon was an enormous shark that roamed the Lowcountry's waters from 1.5 to 28 million years ago. It could grow up to sixty feet long and fed on prehistoric whales and just about anything else it wanted to. It was the greatest predator ever known and had no enemies. Its teeth were approximately seven inches long, and with rows of thousands of these teeth and a bite pressure of between 10.8 and 18.2 tons, it could crush the skull of a prehistoric whale with minimal effort. The average Greyhound bus is fifteen feet shorter than the length of a megalodon and the creature had a bite pressure of ten times more than that of the great white shark, its closest living cousin.

Locating a fossil of the Earth's greatest predator can be rewarding in a number of ways. Just the simple fact of holding a 28-million-year-old fossil is reward enough to many. To others, it is the fact that these fossils are greatly sought after and can fetch a price of $300 to upward of $1,000, depending on its size and condition. In an effort to control the recovery of these and other relics, the State of South Carolina has established laws pertaining to the collection of artifacts and fossils located beneath the state's waters. One must apply for and

Above: Megalodon teeth, depending on size and condition, can be sold for upward of $1,000. *Courtesy of author.*

Left: The author with an artifact recovered in South Carolina waters. A license must be obtained and all underwater archaeological discoveries must be logged with the Sport Diver Archaeological Management Program. *Courtesy of Lost in Legend.*

obtain a collector's license through this state's Sport Diver Archaeology Management Program (SDAMP) and categorize, log and report all findings quarterly. An artifact report must be sent to the South Carolina Institute of Archaeology and Anthropology (SCIAA) on any relics or artifacts located, and a fossil report must be submitted to the South Carolina State Museum on any fossils located. Even with these requirements, many divers enter into the state and risk the dangers of dark water diving (minimal visibility) and black water diving (no visibility) to locate these teeth.

That's what lured three young and relatively inexperienced divers into the waters around the USS *Yorktown* in 1990.

The three divers entered into the waters of the Charleston Harbor in the area of Patriots Point. The visibility was extremely limited and murky, and tides and obstacles made navigation difficult and strenuous. In the end, only two divers surfaced.

The two divers attempted to search for their colleague as trained, but the efforts were unsuccessful. They were able to contact emergency services, and as time passed and the diver was not located, the hopes of a rescue faded and the focus was turned toward a recovery of the diver's body.

The Charleston County Police Department's Underwater Recovery Team had been activated to assist in the search after the Charleston County Rescue Squad had been unable to locate the diver. Justin entered the murky water with others searching in the area the diver had last been seen. The divers began to set up search patterns and systematically began to look for the missing diver. Due to the murky water, the search was pretty much limited to feel since sight was useless.

As Justin began to search the waters adjacent to the USS *Yorktown*, he wondered if the diver had managed to reach the aircraft carrier and had become trapped near the propellers. This would have created an overhead environment. An overhead environment is a condition when a solid object such as thick ice, a cavern roof, or the bottom of the ship in this situation comes between a diver and the surface. An inexperienced diver in near zero visibility may have panicked, become disoriented and used up his air supply seeking an escape.

Justin approached the carrier, continuing to search by touch. As he swam along, he was overcome with an overwhelming sense of dread. It was not his usual apprehension; this was more serious. As he was about to ascend to a more comfortable depth, he realized that something had grabbed his fin and was holding it tight. Experience and training set in and Justin slowly felt down his leg and attempted to reach what had apparently snared him. He examined the fin as best he could with his light. He soon realized he had become entangled in fishing line, and a treble hook had penetrated his fin. Justin decided to adjust his buoyancy compensator (BC) and attempted to descend in order to create slack in the line drawn tight around his leg. That is when he realized that his leg was not the only entanglement issue he was faced with.

His tank was ensnared also.

Justin quickly realized that he was not moving anywhere.

In moments like this, the urge to panic becomes overwhelming. You are trapped underwater on a limited air supply with the knowledge that your survival depends on you reaching the surface. You now realize you are entangled, your ability to reach the surface is impaired and your survival is in jeopardy. Adrenaline kicks in, your heart races and, as it does so, you begin to breathe faster. Your body naturally reacts to the threat in the manner that it was designed to, but unfortunately, that natural physiological reaction to stress begins to burn your air supply even faster. If you struggle, you burn air even faster.

Justin fought back the urge to panic. He watched the bubbles of his breathing rise inches in front of his mask. He focused on the bubbles to calm his breathing. The fact that they were rising told him that he was upright and the surface was exactly where it needed to be, above him. He knew from experience that often times divers can become disoriented in a crisis situation and not realize where the surface is.

In 1990, the Charleston County Police Department served as law enforcement for the unincorporated areas of Charleston County. The Charleston County Sheriff's Office was a much smaller agency and dealt with the security of the courts, the detention center and the service of legal papers. Although the police department dive team had been around for a number of years, many of the officers were using their

own gear or borrowed gear. A communication system was nonexistent. Due to the poor visibility, Justin was separated from his partner and had no way to contact anyone. He was alone, and only he was going to be able to save himself.

As Justin began to work with the lines around his ankle, he considered his options. If he dropped his weights, he would be unable to descend to create slack in the cable around his leg. If he removed his BC to untangle his tank, he may lose control of it and be dragged to the bottom by the lines around his ankle. If he inflated his BC and dropped his weights he could very well shoot upward and be snatched back into even more lines. He chose to remain as calm as he could, conserve air and first work the lines around his ankle and begin to cut himself free.

Justin wondered if this is what the missing diver encountered. He wondered what the diver's last thoughts were as he remained held fast in a spider web of monofilament lines and his air ran out. He wondered what option the diver took, and he wondered what must have gone through the young diver's mind in those final seconds. He then began to wonder why he was wasting time wondering. Justin looked down and chose to descend as much as he could. Logic dictated that the lines' point of origin was downward. He knew which direction downward was because he could see which way his bubbles traveled.

Justin chose to descend in hopes of creating slack.

In dark water diving, the water has two colors of visibility. Those colors are yellow or murky brown. In black water diving, there is no visibility. Justin was in water that was somewhere in between. As he kicked, his fins caused the pluff mud and silt on the bottom to rise up and mix with the already murky water, creating even worse visibility. As Justin glanced around him, he looked upward and was amazed to see another color through the murky mess.

Khaki.

Justin stared in total amazement at the color. It was so out of place yet so clear in such murky water. As he stared and focused upon it, he realized that it was a man in a khaki uniform, a navy uniform, above the surface, and he was reaching down toward Justin over the side of a boat. Justin could not believe what he was looking at, and the fact that he was

apparently closer to the surface than he had thought. He also realized that the coil around his ankle had slackened its grip. Justin kicked hard to break free from the cable and simultaneously inflated his BC and rose to the top. He could see his bubbles breaking at the surface as he continued to rise upward toward the sailor. Just as he was about to break the surface, he was held fast again. Just as he had suspected, his rapid ascent had pulled him up into even more lines that began to entwine his legs. Justin's arms had broken the surface, and he continued to fight his way to the top. Immediately, he was grabbed by not one person, but several. As he kicked, he felt the lines release from his legs as other divers pulled him from his BC and onto the boat. He was completely covered in mud.

As Justin looked around, he realized that there was no sailor on board. There was no khaki uniform. There were no other boats in sight. In fact he could not see at all. It was not until he removed his mask that he realized that it was completely covered in mud. An eerie feeling immediately overcame the exhausted diver. What had he actually seen and how was he able to see it?

The others removed Justin's buoyancy compensator and tank. To everyone's amazement, the fishing lines had wrapped and tightened themselves in a figure eight around his tank. As they worked on pulling at the lines, the rescue crew realized these fishing lines were entangled in ropes with treble hooks embedded into them. These ropes were attached to additional ropes, mooring lines and even more assorted monofilament line and hooks. All this was, in turn, hooked into assorted railings and other metal debris. Justin had inadvertently become entangled in an underwater spider web of assorted debris washed off the ships at Patriots Point and most likely the USCGC *Comanche* a year earlier during Hurricane Hugo.

Due to the danger of the area and Justin's deadly entanglement, the recovery effort was called off. Approximately a week later, the missing diver floated to the surface. His BC was inflated and his air supply diminished, leading many to speculate that he had indeed become entangled and unable to free himself until the tides in the harbor did it for him.

The following year, in 1991, the citizens of Charleston County voted to merge the Charleston County Police Department with the

Charleston County Sheriff's Office, under the direction of Sheriff J. Al Cannon Jr. The Underwater Recovery Team, among all other divisions, benefited from the merger, and better equipment and an underwater communication system were purchased in an effort to prevent such issues as Justin faced that day.

According to Justin, he is not quite ready to admit that the figure he saw was a ghost or phantom. He does admit, however, had it not been for his training, his experience and that inexplicable apparition in khaki, he may have never escaped certain death in the waters at Patriots Point.

NOT ENOUGH COOKIES?

The recipe for whipping up a batch of ten thousand chocolate chip cookies requires a massive mixer, at least one extremely gigantic bowl and the following ingredients:

Ingredients:
165 pounds of flour
500 eggs
100 pounds of granulated sugar
87 pounds of shortening
75 pounds of brown sugar
12 pounds of butter
3 pounds of salt
3 cups of vanilla extract
1 quart of water
1.5 pounds of baking soda

You may ask yourself, "Why would anyone need a recipe for ten thousand chocolate chip cookies?" Well, if you are attempting to bake a batch of cookies for the crew of the USS *Yorktown*, then the answer to that question is obvious. Satisfying every sweet tooth on a ship that can house 3,500 sailors requires breaking quite a few hundred eggs.

Yorktown crewmembers at meal time. *Courtesy of Patriots Point.*

The above recipe is posted onboard the USS *Yorktown*, just outside the bakery area, but obviously there were not enough cookies to go around to satisfy *all* the diners when Lori VonDohlen was cleaning up after a Boy Scout event in the fall of 2011.

Ever since the USS *Yorktown* first docked at Patriots Point, it has served as a location of both learning and adventure for the Boy Scouts of America, as well as Girl Scouts and church and educational groups. Many youths have spent the night on "the Fighting Lady," and just as many Boy Scouts have utilized that time to earn merit badges in fields pertaining to aviation, astronomy, journalism and oceanography. Others may be fortunate enough (or unfortunate enough, depending on your perspective) to experience an encounter such as Troop 149 did on a cold February night in 1987, but that's another story for the next chapter.

On a cold and rainy morning in either late September or early October 2011, the Boy Scouts had just finished dining in the room adjacent to

the CPO Galley or what is referred to as the big room. The sounds of laughter and excitement had subsided, and now that the scouts had left, Lori busied herself cleaning up behind the boys. She was completely alone in the room at 8:00 a.m.

As usual, Lori swept up the place and then wiped down the tables. It was an activity she had done numerous times before by herself, and usually she enjoyed the quietness, but this particular day was different. There was something eerie and unusual about the quiet.

Lori continued wiping down the tops of the tables and then began the task of pushing all the chairs under the tables. Once this was completed, she stepped into the adjoining CPO Galley and began straightening up in that room. She was gone no more than ten minutes when she quickly stepped back into the adjoining dining room to discover that the chairs had been pulled out from underneath the tables. The chairs were in complete disarray and left at various angles in the aisles. This had all been done without a single sound while she was alone in the very next room.

The dining room, where chairs inexplicably rearrange themselves. *Courtesy of KOP.*

Lori quickly replaced the chairs under the table, and as soon as she was done, she ran from the room back up to her office.

In the time that has passed since that encounter, Lori has learned that whatever haunts the galley is not there to harm her. In fact, she thinks that, whatever it may be, it is playful and actually enjoys getting a reaction from her. She thinks it does these "pranks" and gets amusement from others' reactions like some paranormal practical joker.

For example, there have been additional instances where she has been in the CPO Galley and been startled to hear something slam against the wall next to her as if some invisible object had been tossed across the room. She has also experienced a passageway door opening on its own accord in the very same room as her encounter with the chairs. She states the door, which is extremely heavy and difficult to operate, opened on its own and came to rest against the wall. She secured the door only to have it reopen all by itself and return to rest against the wall…an action that is physically impossible for the door to do by itself.

Lori has become a little more at ease with the teasing, but she has taken some precautions in order to avoid such encounters if she can help it. She does her best to try to avoid being alone in that area.

THE PHANTOM LIGHTS OF THE USCGC *COMANCHE* (WPG-76)

In their book *Haunted Harbor*, authors Geordie Buxton and Ed Macy tell the story of what has become the largest group to ever witness a paranormal event on board the USS *Yorktown*. In all, eighteen witnesses from Boy Scout Troop 149 would share in a ghostly encounter between the USS *Yorktown* and the USCGC *Comanche* on February 2, 1987.

The temperature that Monday had been well into the sixty-degree range until sundown. The troop had been busily reliving the day's activities after dinner, and they were not in much of a hurry to pitch their tents on the aircraft carrier's Flight Deck. This was because

the temperature was beginning to drop, and the boys were not too anxious to leave the enclosure of the ship for the exposure of the open landing strip.

The boys' counselor, Art Clawson, had the boys walk out on the strip and begin to set up their tents. As they worked and the sun began to set, the temperature began to drop. Pretty soon the chilly night air caused a thick layer of fog to rise up from the harbor's sun-warmed waters.

When all the boys' tents were up, the cold scouts crawled inside. In the darkness, the visibility dropped to less than one hundred feet as the clouds covered the waters, the landing strip and the tents. Clawson began to verify that each scout was accounted for. He would stand by a tent and call the scout's name, and then he would verify that the scout was indeed inside and in his sleeping bag. He confirmed that all the scouts were accounted for.

Two and a half hours later, Art Clawson made his final head count before turning in himself. That is when he discovered one of the scouts was missing. Nine-year-old Michael Finch was nowhere to be found.

Clawson walked nearly the entire 888-foot length of the Flight Deck until he located the missing scout standing at the edge of the starboard end of the carrier. The counselor slowly approached the boy and cautiously placed his hand on his shoulder so as to not startle the young scout.

"What is it? We have a big day tomorrow," Clawson said.

The boy just continued to stare at the water. Clawson stepped to the railing and did likewise. That is when he saw what had captured Michael Finch's attention and mesmerized the boy.

At first there were just a few of them. They appeared to be red lights, soft red lights just below the surface of the water.

The lights continued to appear, rising up to the surface of the water and shining through the fog. Pretty soon, the Coast Guard cutter *Comanche*, which was berthed there at the time, was completely surrounded and visible and bathed in an eerie red glow.

The glowing red lights continued to grow in number and intensify. So did the number of scouts who joined Art Clawson and Michael Finch. Pretty soon, the entire troop was mesmerized by the sight of the red lights. The two had not realized that the intense red glow had awakened

the other sixteen. In the next three minutes, there were hundreds of lights in the water around the *Comanche*, according to the eighteen witnesses.

Clawson described the intensity of the experience as equal to watching an alien spacecraft land. Everyone was speechless, and there was no sound…except for what sounded like singing in the harbor, way off in the distance. The singing, although faint and distant, sounded familiar. It sounded like a hymn.

Eventually the lights began to fade individually. One by one, they vanished into the harbor beneath the USCGC *Comanche*. The troop was speechless at first but slowly began to question each other for verification that they had actually seen and felt what they had just experienced.

The troop eventually returned to their tents, but no one slept the rest of the night. They were either too frightened to sleep or too excited to tell their tale the next morning.

Perhaps a paranormal occurrence had allowed Troop 149 to witness events that the USCGC *Comanche* had seen forty-four years earlier.

———————◆•———————

One branch of the service that is often overlooked for its service during times of war is the United States Coast Guard. The average person does not realize the contributions that the Coast Guard made in preserving the daily freedoms that we enjoy.

During World War II, 231,000 men and 10,000 women served in the Coast Guard. Of this group, 1,918 made the ultimate sacrifice by giving their lives in service.

In the spring of 1941, Coast Guard cutters were assigned to the United States Navy. They were not only assigned port security, beach patrol and search and rescue as we readily recognize today but they also participated in amphibious landings, Long Range Navigation (LORAN) duties and anti-submarine warfare escorts.

Coast Guard ships sank at least eleven enemy submarines and rescued more than 1,500 military personnel that survived enemy torpedo attacks. The cutters on escort duty saved an additional 1,000.

The USCGC *Comanche* was one of those cutters.

The *Comanche* was commissioned on December 1, 1934. She was originally stationed at Stapleton, New York, which remained her homeport until 1940. At Stapleton, she carried out the standard operations of the Coast Guard at that time, including light ice-breaking on the Hudson River.

In 1940, the USS *Comanche* transported the first American consul to Ivigtut, Greenland, at the invitation of the Danish government-in-exile. This made history by beginning a close association between Greenland and the United States and, in particular the Coast Guard, during World War II. On June 1, 1941, the *Comanche* was assigned to the newly established South Greenland Patrol and was permanently transferred to the United States Navy on July 1, 1941. She was primarily used for convoy escort through Greenland's waters.

On January 29, 1943, the *Comanche* was assigned as an escort along with the *Tampa* and *Escanaba*. They departed from St. John's, Newfoundland, escorting convoy SG-19. This was a convoy consisting of the USAT *Dorchester*, SS *Biscaya* and SS *Lutz*. Convoy SG-19 was bound for Greenland.

During the early morning of February 3, 1943, the German U-Boat *U-223* fired five torpedoes at the convoy. One of the first torpedoes struck and exploded against the *Dorchester*, on her starboard side. The *Dorchester* was formerly a merchant ship that had been converted to military use in February 1942. She was now serving as a U.S. Army transport ship, and just one year into her service, she was the victim of a German U-boat.

Hans J. Danielsen was USAT *Dorchester*'s captain during convoy SG-19. He was concerned and cautious because earlier the *Tampa*, one of the escort ships, had detected a submarine with its sonar.

The *Dorchester* was now only 150 miles from its destination, but the captain ordered the men to sleep in their clothing and keep life jackets on. Because of the engine's heat, many soldiers sleeping deep in the ship's hold disregarded the order. Others ignored it simply because the life jackets were uncomfortable.

Early that fateful morning, at 12:55 a.m., a periscope broke the chilly Atlantic waters. Through the cross hairs, an officer aboard the German submarine U-223 spotted the *Dorchester*. The U-223 approached the

convoy on the surface, and after identifying and targeting the ship, he gave orders to fire the torpedoes.

Danielsen, alerted that the *Dorchester* was on fire and sinking, gave the order to abandon ship. In less than twenty minutes, the *Dorchester* had disappeared beneath the Atlantic's icy waters.

The torpedo strike had knocked out power and radio contact with the three escort ships. The *Comanche*, however, saw the flash of the explosion. It responded and then rescued 97 survivors. The *Escanaba* circled the *Dorchester*, rescuing an additional 132 survivors. The third cutter, *Tampa*, continued on, escorting the remaining two ships.

On board the *Dorchester*, panic and chaos immediately had set in. The blast had killed scores of men, and many more were seriously wounded. Others, stunned by the explosion, were groping in the darkness. Those sleeping who had ignored the captain's earlier orders rushed topside with little or no clothing and no life jackets. They were immediately confronted first by a blast of icy Arctic air and then by the knowledge that survival for them was hopeless.

According to eyewitnesses, men jumped from the ship into lifeboats, overcrowding them to the point of capsizing. Others tossed rafts into the Atlantic, which quickly drifted away before soldiers could get in them.

Although pandemonium and chaos had erupted throughout the ship, four army chaplains brought hope among the chaos. Those chaplains were Lieutenant George L. Fox, a Methodist minister; Lieutenant Alexander D. Goode, a Jewish rabbi; Lieutenant John P. Washington, a Roman Catholic priest; and Lieutenant Clark V. Poling, a Dutch Reformed Protestant minister.

The four chaplains spread out among the soldiers. There they tried to calm the frightened, tend the wounded and guide the disoriented toward safety. "Witnesses of that terrible night remember hearing the four men offer prayers for the dying and encouragement for those who would live," said Wyatt R. Fox, son of Reverend Fox.

One witness, Private William B. Bednar, found himself floating in oil-smeared water surrounded by dead bodies and debris. "I could hear men crying, pleading, praying," Bednar recalled. "I could also hear the chaplains preaching courage. Their voices were the only thing that kept me going."

Another sailor, Petty Officer John J. Mahoney, tried to reenter his cabin, but Rabbi Goode stopped him. Mahoney, concerned about the cold Arctic air, explained he had forgotten his gloves.

"Never mind," Goode responded. "I have two pairs." The rabbi then gave the petty officer his own gloves. In retrospect, Mahoney realized that Rabbi Goode was not conveniently carrying two pairs of gloves, but rather that the rabbi had decided not to leave the *Dorchester*.

By this time, most of the men were topside, and the chaplains opened a storage locker and began distributing life jackets. It was then that engineer Grady Clark witnessed an astonishing sight. When there were no more lifejackets in the storage room, the chaplains removed theirs and gave them to four frightened young men.

"It was the finest thing I have seen or hope to see this side of heaven," said John Ladd, another survivor who saw the chaplains' selfless act.

Ladd's response is understandable. At this moment, all barriers were removed. There was no race nor religion at this point. The chaplains simply gave their life jackets to the next man and continued their prayers and assistance of others. This was the epitome of unconditional love for one's fellow man.

As the ship went down, survivors in nearby rafts could see the four chaplains—arms linked and braced against the slanting deck. Their voices could also be heard offering prayers and singing hymns.

Of the 902 men aboard the USAT *Dorchester*, 672 died, leaving 230 survivors. When the news reached American shores, the nation was stunned by the magnitude of the tragedy and heroic conduct of the four chaplains.

That night Reverend Fox, Rabbi Goode, Reverend Poling and Father Washington passed life's ultimate test. In doing so, they became an enduring example of extraordinary faith, courage and selflessness.

The Distinguished Service Cross and Purple Heart were awarded posthumously December 19, 1944, to the next of kin by Lieutenant General Brehon B. Somervell, commanding general of the Army Service Forces, in a ceremony at the post chapel at Fort Myer, Virginia.

A Special Medal for Heroism was authorized by Congress and awarded by President Eisenhower on January 18, 1961. The special medal was intended to have the same weight and importance as the Medal of Honor.

———◆ ●———

The *Comanche*'s first indication of trouble came from the convoy at 0102 on that morning. A white flash was observed to come from the *Dorchester*, just aft her smokestack. This flash was followed by a visible cloud of black smoke and the sound of an explosion. There immediately followed two blasts from the whistle of *Dorchester* and lights were seen to flash on in numerous spots on the ship.

At 0104 (1:04 a.m.), the officer of the deck of *Comanche* sounded the general alarm and all stations were manned. At 0112 (1:12 a.m.), the *Comanche*, in accordance with prearranged instructions, commenced maneuvering to intercept and destroy any enemy submarines in the vicinity. At this time, all lights left burning on *Dorchester* went out, and it is believed she sank immediately after this at 0120 (1:20 a.m.).

From the time the *Dorchester* was struck by the U-223's torpedo until the time she slipped beneath the waters was eighteen minutes.

At 0226 (2:26 a.m.), the *Comanche* raced to the scene to assist the *Escanaba* in a joint rescue effort after both had received instruction from the escort commander. When the *Comanche* arrived at the scene at 0302 (3:02 a.m.), she passed through an enormous oil slick. Within the slick were numerous red lights. As the number of lights increased, the crew of the *Dorchester* realized that they were the red lights on the life jackets of the dead and dying crew. They watched in horror as more and more rose to the ocean's surface. Hundreds of the red lights floated on the surface, bathing the *Comanche* in an eerie red glow. Hundreds more began to rise from the depths. These new lights were obviously attached to the life jackets of those who had perished on board the Dorchester and were now drifting free from her as she came to rest on the bottom of the Atlantic.

The *Comanche* attempted to rescue some of the men by calling them to the ship, but upon attempting this, it was discovered that the men in the glowing red life jackets had already perished or had become unconscious due to hypothermia and were unable to respond or act in any way.

When an individual first hits cold water, he is faced with panic and shock. Cold water robs the body of heat thirty-two times faster than cold

air. The initial drop in temperature immediately places a severe strain on the individual. The immersion into the cold water immediately creates numbness in the extremities to the point of uselessness. The men in the water would have been unable to adjust the straps on their own vests, let alone grab onto a rescue line.

Within mere minutes, severe pain begins to override rational thought processes. This is all before hypothermia sets in. After the onset of hypothermia, if the victim is not immediately rescued and administered first aid, they will slip into unconsciousness and die.

The normal human body has a temperature of 98.6 degrees. At 96.5 degrees, the body senses that it is cold and begins to slightly shiver. When the body's temperature drops to 94.0 degrees, amnesia sets in. As the body approaches 84.0 degrees, the person becomes unconscious, and as the body drops to 79.0 degrees, death occurs.

Other factors that these men faced were the fact that the torpedo attack occurred in the early morning hours. Most men were sleeping and poorly dressed. The major areas that heat escapes the body are the head, neck, armpits, chest and groin. Sleeping men in their underwear are not prepared for immersion in cold water, and eighteen minutes on a burning and sinking ship is not a lot of time to prepare.

The onset of hypothermia was rapid. Due to the fact that these men were most likely swimming away from the *Dorchester* or treading water, they lost body heat more rapidly. Swimming can decrease survival time by more than 50 percent, compared to just remaining motionless. These were improperly dressed men swimming away from a burning and sinking ship. Without intervention and immediate rescue, they had no chance.

Also take into consideration that cold water is defined at being below seventy degrees. The *Comanche* was an escort and an ice cutter. Water freezes at thirty-two degrees, so we can assume that the waters were, at most, thirty-two degrees. In waters thirty-two degrees or less, unconsciousness can take place in as little as fifteen minutes.

With the survivors suffering from hypothermia and therefore unable to climb aboard a rescuing vessel, the *Comanche* put into operation the "retriever" method. This proved to be the only option available to save

lives. This technique involved having a crewman, dressed in a special suit, jump overboard with a line tied around him. The "retriever" would then grab a survivor, and then crewmen on board the cutter would then haul both men on deck. Three officers and nine enlisted men from *Comanche* acted as "retrievers" that night.

Altogether *Comanche* rescued a total of ninety-seven survivors, mostly through utilizing the new rescue technique involving the use of a "retriever." One of those retrievers was Stewards-Mate First Class Charles Walter David Jr.

David served his country at a time when the service was segregated. Because of race, he was barred from the officer ranks and limited in his enlisted specialty. Despite this, David exercised the Coast Guard's core values of honor, respect and devotion to duty to the highest measure.

The *Comanche* was on scene with the *Dorchester*, and its crew desperately searched for survivors in the frigid North Atlantic waters. David fearlessly volunteered to leave the safety of the *Comanche* to dive overboard, with water and air temperatures below freezing, to help in the rescue of the *Dorchester*'s crew.

One of the men David ended up saving that day was the *Comanche*'s executive officer, Lieutenant Robert Anderson. Anderson had fallen overboard, and after the exhaustion stage of hypothermia set in, he was unable to pull himself out of the water. Using the retriever technique, David was able to tie a line around Anderson, and the crew aboard the *Comanche* hoisted him to safety.

After the last of the survivors were pulled aboard, David began to climb the cargo net to the ship's deck. One of David's shipmates, Storekeeper Richard Swanson, had also volunteered to dive overboard to assist with the retriever technique rescue but was having trouble climbing the net due to the loss of feeling in his extremities. David encouraged his friend to continue, but Swanson was quickly succumbing to hypothermia. David again descended the net and, with the help of another crewmember, pulled Swanson back up to the *Comanche*'s deck.

After saving so many lives, David died a few days later from pneumonia that he contracted during his heroic efforts to save the *Dorchester*'s survivors and members from his own crew. He was posthumously awarded the

Navy and Marine Corps Medal for his bravery, which was received by his wife and son, Kathleen and Neil David.

Richard Swanson, the last man he returned to save, described David as a "tower of strength" on that day, and his heart and commitment to his shipmates was something to be revered.

The *Escanaba* rescued 132 survivors from the *Dorchester*, but 4 officers, 98 crewmen and 558 passengers (primarily army personnel), as well as 16 Coast Guard members, perished. In the presence of the *Comanche*, 578 men died. Ironically, a year later, the hunter would find himself to be the hunted.

On March 29, 1944, three British ships searching north of Sicily located the U-223 by sonar. The three destroyers—*Laforey*, *Tumult* and *Ulster*—commenced a relentless chase that lasted about twenty hours. During the day, the group was reinforced by three other British destroyers: the *Blencathra*, *Hambleton* and *Wilton*; two American destroyers: the *Ericsson* and *Kearney*; and three American Patrol Coastal Ships: the PC-264, PC-556 and PC-558. In this hunt, the various Allied warships carried out twenty-two separate depth-charge attacks, but U-boat Commander Peter Gerlach went to a depth of 772 feet, and the boat survived.

With the large pack of hounds bearing down on him, the biggest problems for Gerlach and his crew were the lack of oxygen and battery power. Finally, after about twenty-five hours submerged, Gerlach was forced to surface in the darkness. He aired the boat and tried to sneak away on his diesels while charging his batteries. Four British destroyers—the *Blencathra*, *Hambleton*, *Laforey* and *Tumult*—detected U-223 and opened fire with guns. Gerlach and U-223 returned fire and destroyed the *Laforey*. The other ships rescued only 69 of the Laforey crew; 189 men perished.

Gerlach concluded that the U-223 was doomed, and he ordered the crew to assemble on deck in life jackets and abandon ship. The twenty-one-year-old engineer, Ernst Sheid, set the scuttling charges and was the last man out of the boat. Gerlach told Sheid that he, as a commander, was "no good without his boat" and chose to go down with her.

While the boat was underway at full speed, Sheid and the others leaped over the side.

As the destroyers hammered the U-boat with gunfire, it suddenly circled back. It is unknown if Gerlach was alive and still at the helm or

if other forces were guiding U-223, but she turned and travelled directly through her crew bobbing in the water. U-223's propellers, along with the gunfire that she attracted from the attacking allied ships, killed almost half of the German U-boat's crew.

After destroying the Nazi submarine, the attacking allied ships rescued only twenty-seven of the fifty Germans who made up the crew of U-223.

On April 23, 1946, the *Comanche* was placed in reserve status except for a six-day period in 1947. On July 29, 1947, she was decommissioned and placed in storage at the Coast Guard Yard in Curtis Bay, Maryland. A year later, she was declared as surplus and sold to the Virginia Pilots Association.

In 1984, the *Comanche* was donated by the Virginia Pilots Association to Patriots Point. In the five years she remained there, approximately a half a million dollars was spent to repair and restore her.

Around midnight on September 22, 1989, Hurricane Hugo—a Category 4 storm with estimated maximum sustained winds of 135–140 miles per hour—made landfall just north of Charleston, South Carolina, at Sullivan's Island. Hugo produced tremendous wind and storm surge damage along the coast and even produced hurricane-force wind gusts all the way into western North Carolina. In fact, Hugo produced the highest storm tide heights ever recorded along the U.S. East Coast.

Despite the best efforts of the staff at Patriots Point, the *Comanche* tore loose from her moorings at the stern, swung around to port and, for the entirety of the storm, repeatedly slammed into the pier, causing irreparable damage. According to a 1991 newspaper article, damages were estimated at another $130,000. After much controversy, the vessel was donated to the South Carolina Department of Natural Resources, and modifications were made in order to sink her and make her an artificial reef. She was scuttled in 1992.

For the past twenty years, Charleston Scuba owners Tom and Sally Robinson have been diving the site. They have never encountered anything out of the ordinary on any dive there, but even though she has become a popular scuba diving attraction, there are still occasional reports of fishermen observing red lights rising to the surface above this great Ghost of War as she rests over a hundred feet below the Atlantic.

THE CHARLESTON NAVAL SHIPYARD MUSEUM:
THE INVISIBLE TOURIST

One of the very first exhibits to be created on the USS *Yorktown* was the Charleston Naval Shipyard Exhibit. The Charleston Naval Shipyard was created when the United States Navy acquired the waterfront property in 1901, and construction began in 1902. The shops and dry dock number one were in place by 1909. In 1913, the shipyard built its first vessel. It would go on to build another 252.

During World War I, the shipyard's employment had reached over 1,700 employees, and it built its first warship, the USS *Asheville* (PG-21). The Charleston-built ship served for quite some time and entered into World War II. The USS *Asheville* was one of the few American surface ships lost without a trace and with no known survivors at the end of the war. It had just simply vanished, and her fate was not learned until quite some time after World War II had ended: on March 3, 1942, the Charleston-built warship was destroyed by the Japanese.

Hampered by engine troubles and sailing alone, the USS *Asheville* had been discovered by a Japanese scout plane and overtaken by a Japanese destroyer squadron consisting of the destroyers *Arashi* and *Nowaki* and the heavy cruiser *Maya*. As the cruiser stood by, the two Japanese destroyers closed and engaged the USS *Asheville* at close range with their guns. After an intense thirty-minute gun battle, the burning bulk of the USS *Asheville*, its superstructure almost completely destroyed, finally sank. After calling out to find out if there was an officer among the swimmers, one survivor—eighteen-year-old Fred L. Brown, from Fort Wayne, Indiana—was picked up by a Japanese destroyer. This was done, more than likely, simply to identify which ship the Japanese Imperial Navy had just sunk. Afterward, the remainder of the survivors in the water were shot to death with machine guns or just left to the sharks. Brown later died in a POW camp in March 1945. If not for the fact that Brown had told several of his fellow prisoners his story, no one would have ever known what had been the fate of the first gunboat created by the Charleston Naval Shipyard during World War I.

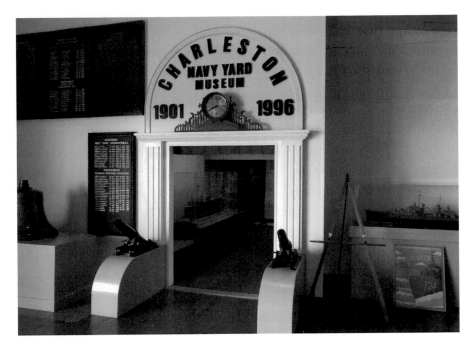

The Charleston Naval Shipyard Museum. *Courtesy of KOP.*

After World War I, the shipyard concentrated on the maintenance of minesweepers and gunboats. In 1933, it was upgraded to a new construction shipyard.

When the United States entered into World War II in 1941, employment was up to nine thousand, which made the shipyard the largest industrial employer in South Carolina's history. By 1943, just two years later, employment had grown to just under four times that amount. Out of twenty-six thousand employees, five thousand of those were women. Those employees built, repaired and maintained the ships involved in the war. The shipyard expanded with three additional dry docks, and the Charleston Naval Shipyard built 20 destroyers, 17 destroyer escorts, 92 medium landing ships, 9 fast troop transports and 1 destroyer tender, plus an additional 77 ships. Out of these 216 vessels, 12 were lost, including a quarter of the destroyers it had built.

After World War II, the shipyard's emphasis turned to the repair, overhaul and conversion of ships and submarines. By 1959, the shipyard

prepared to begin refueling and overhauls for nuclear submarines. Even though the Charleston Naval Base was the third-largest in the United States, it became a casualty, along with the Charleston Naval Shipyard, as the Cold War drew to an end.

On March 15, 1996, the Charleston Naval Base and Shipyard closed. Thirty-six employees of the shipyard joined with staff at Patriots Point and gathered and contributed artifacts and memorabilia to expand the exhibit onboard the USS *Yorktown*. The exhibit fully encompasses every aspect of the Charleston Naval Shipyard's ninety-five-year history. It has always been an exhibit of great interest to many who have taken the tour of the USS *Yorktown* during her open hours, but there was an occasion, many years ago, when the exhibit apparently created some after-hours interest.

During her time in service, the USS *Yorktown*'s security was enforced by the ship's personnel and also the United States Marine Corps. Today, the ship's security falls under the care of Patriots Point security personnel and also the Mount Pleasant Police Department when they are called to assist the security division.

On one occasion, a security officer was working the night shift and was present for an occurrence he had never witnessed before. During that time, the Charleston Naval Shipyard Museum had motion-activated speakers that, when activated, would provide the visitor with information regarding that particular display. According to the officer, it was not unusual for one or even two displays to simultaneously activate on clear nights due to Radio Frequency Interference (RFI) from their radios. This particular incident was much different.

As the officer was making his rounds, he heard one of the boxes activate. He thought little of it initially because he had heard the boxes activate before. What eventually raised concern was when another box activated a short time later...in order of the display. As the boxes continued to activate, the officer requested back-up and a second officer arrived on the scene to hear the next sequential box activate. Ironically, the officer used his radio to call for assistance, and his partner responded using his. Neither device activated any of the boxes in the exhibit. The fact that their radios were not causing the issue and the boxes were going off in order alarmed the security

officers who now believed they had cornered a trespasser in the Shipyard Museum. Both officers cautiously and quietly entered the exhibit from the exit and proceeded to search the area backward from exit to entry in order to intercept the interloper traveling toward them. They fully expected to find a human trespasser wandering through the exhibit. Much to their surprise they found absolutely nothing... and the boxes stopped.

The two security officers continued to search the exhibit backward and forward. They searched all possible hiding spots, but nothing made sense as to what may have activated the boxes in sequential order.

The officers even looked for non-human sources, such as perhaps a rodent or even a raccoon, but even this rationalization made no sense due to the fact that it would have had to get out past one of them and it would have had to be well over two feet tall to even activate the sensors.

Try as they may, the two security officers could not find any source, malfunction or reason for the boxes to have activated as they did.

The Charleston Naval Shipyard Museum: The Shadowy Intruder

Several years ago, in the early morning hours, another security team discovered what they believed to be an intruder below decks. One of the Patriots Point security officers had observed a large shadowy mass moving about the area. This officer observed the shadow to be in the form of a person, and he believed that it was indeed being cast by an unknown subject caught in some of the ambient light below deck. Having seen enough to cause the officers to believe there was a human interloper on the USS *Yorktown*, this particular team contacted the local police department, and two uniformed police officers were dispatched to look for the possible trespasser.

Once again this particular incident took place at the Charleston Naval Shipyard Museum. When the officers arrived, they were briefed by security as to what they had seen. The two officers responded to the

The staircase within the Charleston Naval Shipyard Museum, where several people have encountered a dark apparition. *Courtesy of KOP.*

exhibit, and there they also observed an extremely large dark "mass" moving below them. In a recent interview, one of the officers stated that he and the other officer exchanged glances at the moment of initial contact and each officer asked the other simultaneously, "Did you see that?"

The officers confirmed that they both were indeed observing the same black mass.

As they observed the mass from above, it began to move quite rapidly. The officer stated that the mass was twice his size. Both officers proceeded downward to investigate the shadow, and both observed it move rapidly away from them and vanish. There was no way for the mass to have left the area without passing the officers, and they made an extremely thorough search of the area. The direction that the shadowy mass traveled led to doors that were secured from the opposite side and prevented any possible avenue of escape.

According to Patriots Point personnel, the police officers, eventually satisfied that the area was secure and no threats existed, stated that the shadowy mass "was not human"and "decided to let the security team figure it out."

Shadow People: "Shadow Ed"

Through the years, many additional stories have surfaced concerning shadow figures on board the USS *Yorktown*. Little is known about the paranormal entities known as shadow people, although they are considered to be one of the primary paranormal entities experienced by witnesses.

On the website "The Official Shadow People Archives," Susan Fowler describes this entity as follows:

> *Sometimes it appears as the mere silhouette of a person, usually male, but generally lacking any other characteristics of gender. However, in no way does the description end there. There are "hatted" shadow beings, hooded shadows, cloaked ones, and solid or wispy, smoky types. Some are seen only from the waist up. Others clearly have legs that are seen fleeing from their observers. They dart into corners, through walls, into closets, or behind television sets, bushes, and buildings. Sometimes they simply fade into the dark recesses of the night. Lacking in the description is one common denominator unifying the many different types of shadow people that enter our world, except that they are "intensely dark." But even then, there are exceptions.*
>
> *Finally the question is asked, "What is their purpose?" One thing is for certain, the personalities and intentions of shadow people are just as varied as any one of the six billion people populating this planet. While a number of witnesses believe that shadow people act as benevolent guardians watching and guiding us; just as many witnesses have no doubt of the evil soul-wrenching potential of these beings. Originally, I believed the shadow people to be ghosts, but the stories received, read,*

compiled and uploaded are more convincing that shadows are a type of inter-dimensional beings, from which 'ghost' is only one sub-category. One can only hope that serious research into this paranormal (or psychological) genre will paint a clearer understanding of the nature and make-up of these dark mysterious 'people'. That day has not yet come.

Many of the shadow people experienced onboard the USS *Yorktown* have been attributed to a figure that has been called "Shadow Ed" by Patriots Point personnel. This term has also been picked up by some visitors as well.

The name "Shadow Ed" was derived from a military term meaning "Enemy Designated" or "E.D." Therefore "Ed" is not truly the name of anyone or anything onboard the ship. The term is simply referring to a "Shadow Enemy Designated." According to one Patriots Point employee, there are too numerous occurrences in various locations to be attributed to just one entity.

Around 1998, Chief Electrician Brian Parsons had his first encounter with the entity he referred to as "Shadow Ed." He states that at that time, he was a security officer with Patriots Point and was making his rounds on the second deck in "Officers Country" on the starboard side of the ship. This is the area known as the Forward Officers' Area. As he was walking out of room 200, he felt as if he was not alone, even though the ship was closed to the public and it was after hours. Brian looked over his shoulder and saw someone cross the corridor. He turned to investigate, but once he got to the location where the person should have been, he discovered nothing.

Brian turned around and began heading back in the direction he had originally been traveling. Just when he had chalked the occurrence up to his imagination, he again observed the shadow cross directly in front of him and block out the light at the end of the corridor. At this time, he was convinced that someone else was in the area. Brian contacted his supervisor, and the two of them searched the area without locating anyone.

The following day, Brian shared his story with an employee on the graveyard shift. The employee was not surprised and stated that his shift had experienced the same thing.

Several employees have experienced the shadow people. As one Patriots Point employee, Vernon Brown, states, "You see them just out the corner of your eye. I don't think they want to hurt you, but they will sure make you hurt yourself trying to get away from them."

SHADOW ED: ONE VISITOR'S ENCOUNTER

On the Veterans Forum on the "USS *Yorktown* Sailor" website, a visitor posted her encounter with Shadow Ed during one of her visits to the ship. The following is her story, in her own words from the posting.

I think I have seen him. I was in Charleston, in 1988 and 1989 and visited the USS Yorktown. I had been to visit her many times but this was the first time I had been there when the engine room was open. You have to forgive me due to this being so long ago I am a touch fuzzy. Anyway, while I was down in the engine room, I was looking out over a catwalk type thing/viewing area. Well, this "person" came out from below the cat walk, bent down like it picked something up, looked at a pipe and went back under where I was standing. I don't know how far that platform is where you stand to how far down "this person" was but I remember thinking when I saw him that it must be kinda dark since I never saw any colors on his clothes or hair color, etc. I never saw anything but a dark outline of a person. My first thought was/ is that a homeless person living there without anyone knowing? What's that person doing down there and where did he go? Why didn't he make any noise? Now I wonder if it wasn't a shadow person. I was there in the middle of a weekday so there weren't very many people there. Neither the other couple of people nor my boyfriend saw it but I saw it clear as day. I guess because when I am in these places, as I am looking around, I am picturing what was going on, what they were doing as their ship was being bombed and how in the heck would they get out of there if the ship started sinking.

I love this ship and have visited her many times. Every time I visit Charleston, I find myself wandering around on her or sitting on the fantail. Last time I was there was in the Summer of 2003. Didn't see anything except the sweat rolling in to my eyes!

Thanks for letting me share.

—*Crystal Kell, December 8, 2008*

JUST AROUND THE CORNER

Bruce M. Frey is a clinical pharmacist in pediatrics at the Medical University of South Carolina. As such, he is used to dealing with science and with tangible and "explainable" reality. He is also a volunteer for Patriots Point and has been for quite some time. In this capacity, he has experienced some things that he cannot readily or scientifically explain.

As a Patriots Point volunteer, Bruce has logged many hours onboard the USS *Yorktown*. He has frequently been approached by small children and asked the inevitable childhood maritime question: "Where are the pirates?" The good-natured gentleman then takes the time to explain about pirates and piracy on the seas before transitioning back into the USS *Yorktown*'s place in history. Sometimes there is that rare occasion when a young adult or a parent or two during the tours has approached. Often times the reason is as simple as asking for a restroom to clean up a child or advising him that a child has just puked in the back of the group. Other times, he can often tell by their expressions, there is a more pressing issue on their mind. The question is often asked, "Is this ship haunted?"

That answer is a tad bit more complicated, and quite frankly, he would rather deal with an onslaught of armed pirates by himself than to try and answer their inquiry.

Often times, the adult will go a little bit further and ask about the voices they just heard. Many times, he has had to reassure them that they are not crazy and that they are definitely not hallucinating. He has heard them too.

He has had several experiences of hearing the voices, not just one but several, around the corner as he has been traveling around on the ship.

The Hauntings

He will hear the voices speaking in low tones, accompanied by movement and footsteps. He will turn the corner expecting to run into another tour only to find the corridor empty. He says that either the tour group consists of "the fastest humans on Earth," or there is something else occurring.

He has had these experiences in several locations onboard the USS *Yorktown*, but most often they occur below deck in the Boiler Room, near the turbines or in the pilot ready area. The voices are numerous, but the words cannot be made out. They are a constant murmur combined with shuffling, papers moving and numerous footsteps.

He, like many other employees, has made attempts to locate the party, but the scientific and analytical side of Bruce Frey has already determined that an unnoticed escape by such a large group is impossible. "There is simply no place for them to go."

In discussing the matter with Bruce Frey, he will tell you that if there are really such things as ghosts, then these are men just going about the performance of their duties just as they had in life. He states that these men had lived—and suffered—through the Great Depression. They left behind lives where things were difficult, and perhaps they were struggling to support their families. On the USS *Yorktown*, they had a purpose in life, were able to support their families and were a part of something even bigger; they belonged to a larger family here on the USS *Yorktown*. They lived their lives here, fought side by side with their brothers and some even died here. If there are such things as ghosts, then why would a person not want to return to a period in their life where what they were doing in that moment was the most important thing they ever did in their entire existence?

When speaking of what he has experienced onboard, he believes that the phenomenon is more natural than supernatural. Paranormal means something beyond normal scientific explanation. He truly believes that the events he and many others experience on the ship are beyond current scientific explanation.

He believes that the sounds are quite possibly an echo from the past. As explained earlier in this book, an echo is defined as a reflection of sound, arriving at the listener sometime after the direct sound was created. The sound, or series of sounds, is caused by the reflection of sound waves

from a surface back to the listener. Perhaps these sounds are an echo in time created decades ago, reverberating through the steel walls and decks of the enormous ship and arriving to be heard in the present.

Bruce believes that one day there will be a scientific explanation for the paranormal experiences he and many others have experienced onboard the USS *Yorktown*. Much like the phantom voices in the corridors, he believes that a plausible scientific explanation is just around the corner.

RUDE AWAKENING

Several years ago, Patriots Point employee Brian Parsons was a young high school student working after school and weekends onboard the USS *Yorktown*. He loved the ship, and he spent as much time as he could working there or even just hanging out on the Fighting Lady after his shift. On some occasions, he even worked so late that he ended up sleeping onboard. One such night, Brian was in room 243, one of the smaller officer's staterooms that the scouting department has set aside for Patriots Point staff to utilize on just such occasions. Brian had used this room before as a personal berthing room, and he realized that the door to this particular room did not seem to secure very well. He had wedged a couple of coins in between the door and the frame in order to prevent it from coming open, but he was not too concerned with anyone walking in on him because he was the only one in that immediate area.

It was pretty late at night, and Brian was lying in the bunk, almost asleep. As he lay there, the door was suddenly—and forcefully—thrown open and struck the wall with a tremendous impact. Startled, Brian jumped from the bunk and immediately ran into the hallway.

No one was there.

The room is only approachable by two directions, through the corridor in which it is located. Both these directions are cordoned off by chains hanging across the passageways to keep visitors on the tour route away from these particular rooms. Brian immediately took note of the chains and the fact that they were hooked in place and not moving. It is

Room 243. *Courtesy of KOP.*

impossible to get past the chains without causing them to sway, and had anyone fled in either direction, it would have been indicated by the chains either having been removed or at least swaying at having been touched. Not only were the motionless chains hard to believe, but there was also no noise of anyone moving about the corridor and there was no possible way for anyone to exit the corridor before Brian had gotten to the door.

DRESSING THE PART

Through the years, many visitors have expressed to the staff at Patriots Point that they thought it was a nice touch having some of the staff dress as sailors. The problem is that Patriots Point does not do this and never has. There are, however, mannequins on the ship dressed in period clothing.

Perhaps some individuals have initially mistaken the mannequins for ghosts, but a quick double take soon reveals that they are secured behind Plexiglass and are part of the exhibit.

Quite often, the Patriots Point staff has pointed out the mistaken identity of the mannequins, but there are other times when the visitors report that the people they saw were in motion. There has also been the occasion where a staff member has seen them too.

There has also been an occasion or two when "living" active duty personnel in uniform have been mistaken for staff in costume, but that is rare and quickly resolved.

Visitors have reported seeing such uniformed apparitions in the Boiler Room and the Engine Room. One visitor observed a sailor climbing a ladder leading from the Fantail of the ship.

On one occasion, an employee arrived early one morning and observed a uniformed figure in a flight suit in the Hangar Bay. The person was moving about under a B-25 bomber that is on display in the area of the snack bar. The staff member observed the person moving about beneath the plane as he was traveling toward his office. As he passed the person, he had second thoughts and turned around to inquire why he was there. When he did so, the person was no longer there. The employee says he may have lost sight of the subject for ten seconds or less. He states he simply passed by the man, turned to speak to him and the man was no longer there.

Another visitor reported that as she was passing through a corridor, she observed a sailor painting a door and door frame. His equipment, paint and ladder were partially blocking the hallway. As the sailor continued to paint, the lady leaned against the opposite wall and squeezed passed him. She continued down the corridor and turned around to glance back at the handsome young man. When she did so, she was shocked to see that there was no man, no equipment, no paint and no ladder in the doorway she had just squeezed past seconds earlier.

Another employee report of an apparition occurred when staff members were clearing the ship after the overnight campers had left. The security team had already cleared and secured the billets (the living quarters the campers had stayed in), and a single staff member had begun touring the area while another waited at the base of the exit ladder.

The Hauntings

On this particular occasion, the inspecting staff member encountered a man in a U.S. Navy peacoat, the heavy wool coat worn by naval personnel. The inspecting staff member asked the man what he was doing there, and he turned away from her and went down the corridor that ended at the exit ladder leading to where her assistant was waiting. The subject descended, and the inspector quickly moved down the corridor and did likewise. When she reached the bottom, she was met by the other staff member at the bottom of the ladder. She asked if anyone had exited—in particular, a man in a navy blue peacoat. The answer was no. No one had exited at all after the inspecting staff member had gone up the ladder. Both staff members searched the area again, but no one was located.

In the winter of 2004, Joe Venezia, a longtime volunteer, was walking to his office on the Hangar Deck when he observed an older male in a black navy uniform and peacoat walking through the Hangar Deck. As they were walking toward each other, Joe had an uneasy feeling. He noticed that the individual never blinked, nor did he turn his head toward Joe or the display of vintage aircraft. As Joe passed him, the man didn't slow or acknowledge Joe at all. The subject stopped and stood looking out one of the Hangar Deck stairways toward the harbor. Joe entered the office just long enough to drop the papers he was carrying and reentered the Hangar Deck to approach and question the man. Joe states he was not in the office five seconds, and when he exited, the man was gone. There was absolutely no place for him to have exited the Hangar Deck in the five seconds Joe took his eyes off of him.

In March 2012, Joe was working the information booth when he was approached by a very excited couple from Wisconsin. They had been touring the ship and were on the Flight Deck when they approached the SH-3G Sea King, an enormous helicopter stationed on the deck. The aircraft is an extremely large one, and although it is not impossible, it is very difficult for shorter people to be able to view the cockpit area through its Plexiglass windows. The woman had been having difficulty in doing so herself, so she lifted her camera up and snapped a picture of the interior. When she looked at the picture, she and her family were amazed at what they discovered. The photo appeared to have captured

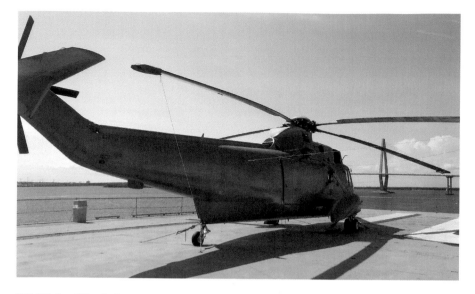

SH-3G Sea King helicopter, where visitors claim to have encountered a ghostly pilot. *Courtesy of KOP.*

a person in a flight uniform inside the cockpit. The person also appeared to be transparent.

The couple rushed back to the information desk and showed their camera to Joe Venezia. He also could not believe what the image appeared to be. In the excitement, he forgot to get their names and information. Perhaps it was an optical illusion played on the Plexiglass by the sun, or perhaps it was something else the woman encountered. After his encounter several years earlier, Joe Venezia believes that, quite possibly, they may have encountered something else.

A FAMILY CONNECTION

There are as many reasons an individual person may visit the USS *Yorktown* as there are stars in the sky. In 1996, one visitor, a former sailor, came to Charleston, South Carolina, and felt *compelled* to visit her. As most folks do when they arrive at the ship, he spent the better

part of the day wandering around. Later, as he started following the designated tour pathways of each of the ship's sections, he had an eerie and overwhelming feeling that someone—or something—was trying to contact him. He felt as if he was being called to a certain area of the ship, and he ended up following that feeling. As he did so, he was surprised to find himself in the hangar bay. He stated that the hair on the back of his neck was standing up for no apparent reason, and as he walked through the hangar, he continued to feel as if something was leading him there to show him something.

The visitor was attempting to shake the eerie feeling and compose himself when he stopped in front of a memorial to four members of VT-1 Torpedo Bombing Squadron who were shot down in July 1944 in a mission over Guam. As he read the four names—Lieutenant Leonard E. Wood, Edward C. Donahue, Alfred Sabol and Owen L. Smith—he was shocked to see that one of the four deceased crew members bore his last name. Just as quickly as the feeling had come upon him, the eerie feeling completely vanished as he stared at his family name on the memorial.

The Carrier Aviation Memorial. *Courtesy of KOP.*

The man returned home and researched the name he had seen on the memorial. As he inquired about the name to his family members, he was not at all surprised to discover that the deceased crewmember was a cousin he had never known. Although a little unnerved by the experience, this particular visitor will tell you that he has no doubts that he was led to the Hangar Deck and that particular memorial on the USS *Yorktown* by his cousin and his cousin's comrades, even though they had been shot down and had died on a mission fifty-two years earlier.

THE WEAPONS LOCKER

One former crewmember was visiting the USS *Yorktown* and requested assistance from Patriots Point staff in locating his former berthing and work areas. While exploring the ship, the individual and the staff member assisting him passed by the small arms locker on the fourth deck and something jarred the former sailor's memory.

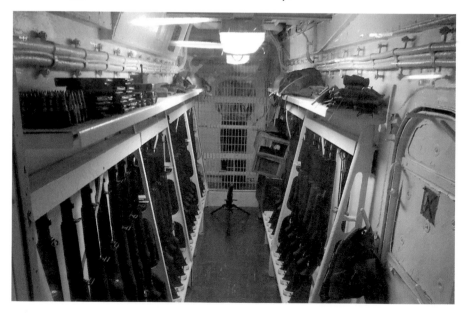

A mannequin dressed in a marine uniform stands guard behind Plexiglass over one of the USS *Yorktown*'s weapons lockers. *Courtesy of KOP.*

The sailor explained that this was an area where one of his close shipmates had once worked. He stated that one day his friend had received a "Dear John" letter from his girlfriend back home, and this sent the young man into a severe state of depression. The man eventually took his own life with one of the pistols at his work station.

Ironically, the employee had experienced very uncomfortable feelings in that particular area of the weapons locker and had also experienced the sensation of someone touching them while passing through this area. It has become an area that this particular Patriots Point staff member now chooses to avoid.

The Haunted Head

In the vicinity of the beginning of Tour 1 is a stairwell that leads below the Hangar Deck to a set of restrooms. It is in this area that many people claim to feel an ominous and oppressive spirit. Both staff and guests have reported that they feel as if they are being followed and watched in the area. One staff member reports that she and others have been known to walk all the way to the opposite end of the ship in order to avoid going down the stairs to the restrooms, also known as the "head." The term comes from the days of sailing ships, when the place for the crew to relieve themselves was all the way forward on either side of the ship's bow, the forward-most part or the head of the ship. It was also the end of the ship where the figurehead was fastened, and therefore there was actually a head at the head of the ship.

In researching the material for this book, this author was told time and time again about the area and warned of the ominous presence. The warnings were given so often that I personally went out of my way to place myself in that area to perhaps experience something.

This author never experienced a thing there.

When the day came for my photographer to board the USS *Yorktown*, this author purposefully took her to this area when "nature called." She—also purposefully—was not informed of the ominous presence to

The restroom known as the ship's head was located above the ship's figurehead on sailing vessels. *Courtesy of Lost in Legend.*

see if she may have an actual (non-suggestive) paranormal experience with the oppressive entity. As I went toward the men's restroom, she headed down the long corridor to the women's restroom alone. She states that she was immediately overcome by a feeling of dread and a feeling that she was no longer alone. The photographer, my eighteen-year-old daughter, stated that there is no worse feeling than having to go to the bathroom and feeling like someone is watching you.

As she entered the women's restroom, the feeling became more intense. She stated that she was completely alone, yet she felt as if there were someone there with her. She felt obligated to inspect the restroom to make certain that she was alone, and when she confirmed that she was, she proceeded to the furthermost stall to "take care of business."

As she settled into the stall, she was concerned with the large pipes that surrounded her. She had images of evil mutated creatures rising from the bowels of the ship, crawling through the pipes and descending upon her stall to devour her. My daughter's fear began to overwhelm her, and she did as she has always done when she is afraid: she began to sing.

As stated earlier, this is my daughter and the apple does not fall far from the tree. Unlike her father, my daughter has a very beautiful singing voice (she got that from her mother). Much like her father, she has a very eclectic taste in music. EXACTLY like her father, she often changes the lyrics.

What song choice does a frightened eighteen-year-old young lady choose to help calm her nerves in the presence of an oppressive spirit while relieving herself on a haunted ship?

"All by Myself" by Eric Carmen.

Quite an appropriate song, yet her modifications made it the perfect song. The lyrics of the 1975 classic hit are:

All by myself
I don't want to be
All by myself
Anymore…

After Kayla's modification, the word "be" was replaced by the word "pee." The child is not responsible for her genetics.

If there were any ghosts within two decks of her, they were rolling on the ground in fits of ectoplasmic laughter as my child, frightened and all alone, sang out loud:

All by myself
I don't want to pee
All by myself
Anymore…

Being a musician, singer and performer, Kayla recognizes great acoustics when she hears them, so her singing grew louder as it echoed through the restroom and then through the ship.

Apparently, the music traveled further than she thought, and God in heaven heard her plea. Unfortunately, Kayla did not get that memo. She was unaware that another woman—a living one—had joined her in the women's restroom. The woman, apparently amused, snickered at the singing. Kayla heard the snickering and thought that perhaps the evil

mutated creatures crawling through the pipes had a sense of humor and enjoyed a good laugh before devouring young ladies as they urinated in restroom stalls aboard haunted ships. Kayla quickly and abruptly finished what nature had started, and she departed the restroom just in time to encounter the other party who had joined her. After mutually frightening each other with minor shrieks of terror, Kayla returned to report her experience. If there was an ominous and oppressive entity in the haunted head, I am sure he will never forget his encounter with my staff photographer.

I know she never will.

AN EERIE PRESENCE

Another visitor, Savannah Silkie, had her own experience with an unseen ominous presence onboard the USS *Yorktown*. She posted her experience with the website known as "Project: Paranormal." Her experience, in her own words, is as follows:

> *Several years ago, I spent a weekend on the USS* Yorktown, *located at Patriots Point in Charleston Harbor. We had gone there with my son's boy scout troop. The* Yorktown *is an aircraft carrier used in WWII and the Vietnam War. After we arrived, the group went to the theater onboard the ship to watch a documentary. I used this time to shower and get refreshed, and was quite alone on the deck on which my cabin was located. Halfway through my shower I got a feeling I was being watched, and shook it off, thinking it was my imagination. The ship creaks and groans, sounding like metal against metal and it is easy to get spooked in such a place. Needless to say, I hurried to finish my shower, and then proceeded to dress and dry my hair. The outlets are located above the mirror over the sink. As I was drying my hair, I had my eyes closed and my head was down, I was not looking in the mirror. Suddenly, I had a chill and felt a presence standing behind me. I was so terrified, I dared not look in the mirror in fear of seeing something*

besides my reflection. It was definitely not a "good" feeling. I reached up and jerked the plug from the outlet, leaving my belongings behind and I literally flew from the bathroom. As I ran down the corridors to my room, one of the heavy metal doors creaked open as I passed by. While I did not see an apparition, I can tell you without a doubt that the presence was ominous. I immediately climbed down the narrow ladder/ stairs to the hangar deck to join the group. Needless to say, I didn't go to the bathroom alone the rest of the trip. Later, I was talking with one of the personnel on the ship, and I asked if they had ever had any reports of ghosts or paranormal activity there. He informed that yes, many, many, times. He then told me the ship had a morgue below, they didn't bury people at sea. The bodies were kept in the morgue and brought back home. He also told me that an apparition of an officer had been seen there by personnel on the ship and by visitors. I just wondered if anyone else had been there or had similar experiences. It would be a very interesting place for a paranormal investigation.

This large metal door, although extremely heavy and difficult to operate, has been known to open by itself, much to the surprise of those in the galley. *Courtesy of KOP.*

After having received so many accounts of activities from both staff and guests, Executive Director Mac Burdette agreed.

It was time for an investigation.

HAUNTED BY HEROES

On October 6, 2004, *Ghost Hunters* premiered on the SyFy channel. The paranormal reality-based series features the investigations of the Atlantic Paranormal Society (TAPS) led by founders Jason Hawes and Grant Wilson. The combination of the investigations and the interaction of the team members has proven itself to be a lasting combination with its audience.

After eight seasons, the show has succeeded in pioneering new techniques and equipment in the field of paranormal investigations and has set the standard that others follow. The January 11, 2012 premiere of *Ghost Hunters*'s eighth season reached two million viewers, and the paranormal reality series was up 16 percent in total viewers.

In 1990, TAPS was founded by Jason Hawes with "the sole purpose of helping those experiencing paranormal activity by investigating its claims in a professional and confidential manner, and using the latest in paranormal research equipment and techniques." *Ghost Hunters* has stuck to TAPS original principles, and because of this, Patriots Point approached the group for assistance in investigating the activity that many have experienced for years on the USS *Yorktown*. The consensus was that the team would treat the ship, her crewmembers—both living and deceased—and her legacy with the respect and honor she deserves.

"While we were intrigued at the notion of paranormal activity aboard 'The Fighting Lady,' our first priority was to make certain that any investigation was handled in a manner that was respectful of the service and sacrifice of the men who served aboard her. The TAPS crew was absolutely wonderful and displayed great patriotic respect throughout the filming," said Patriots Point executive director Mac Burdette.

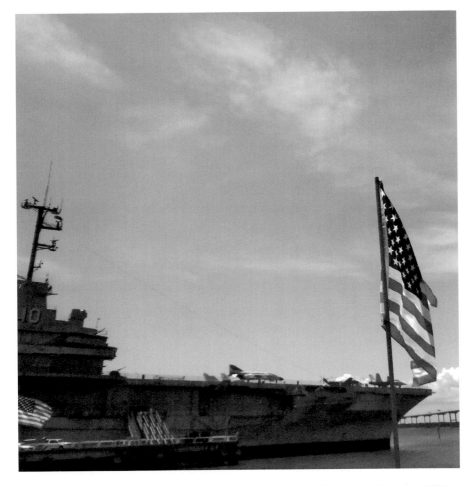

If the USS *Yorktown* is truly haunted, then she is indeed haunted by heroes. *Courtesy of KOP.*

In February 2012, *Ghost Hunters* conducted its investigation of the USS *Yorktown*, and on May 2, 2012, the tenth episode of season eight, the show aired.

During its investigation, the TAPS team was able to validate the Patriots Point staffs' claims. Footsteps, voices and activity were captured in the empty ship, along with recorded evidence of a shadow figure on the Flight Deck, a team member being gently pushed and a full body apparition captured on a thermal imaging camera in the Charleston Naval Shipyard Museum.

TAPS founder Jason Hawes, during an interview with the *Post and Courier*, said what they captured is convincing. "Not only did we catch some of the most compelling evidence I believe we have ever caught and the most intense experiences all team members have encountered in a long time, but it is also known as a hot spot for the very thing we seek—the paranormal."

HAPPENINGS IN THE HANGAR DECK

On July 18, 2012, this author and Rick Presnell spent the evening on the USS *Yorktown*. Rick is more open to "ghostly" occurences, but it takes quite a lot more than a bang or bump in the night to convince this author of paranormal activity. However, by the end of the evening, we would both be scratching our heads and questioning if we had indeed experienced what we thought we had experienced.

Upon our arrival that evening at 6:45 p.m., we were escorted onboard and met with the security shift supervisor, Justin Davis. There would only be myself, Rick, Justin and one other security person onboard during our stay.

Rick and I made a cursory walk-through of the areas we wanted to focus on and then split up for a bit to get the feel of the ship after power had been turned off in the main areas. We then met up on the Flight Deck to gather our thoughts and to also take advantage of the cool evening sea breeze before going back into the ship, which had been baking all day in the one-hundred-degree temperatures. With power turned off to the main areas, the air conditioning—what little there is—was also shut off.

When we returned to the ship, we continued down to the Hangar Deck. As we walked and planned, we listened to the enormous ship creak, pop and groan as her upper deck cooled and contracted in the evening air.

As we stopped in the hangar, we decided that we wanted to set up motion sensors inside the Charleston Naval Shipyard Museum in an effort to simulate events that had previously occurred there. As we were discussing this idea, we both heard footsteps on the catwalk above us. We immediately turned and looked upward, and both Rick and I saw a shadow block out the auxiliary lighting that was illuminating that area.

An F4U Corsair stands as part of a World War II aircraft exhibit within the Hangar Deck of the USS *Yorktown*. *Courtesy of KOP.*

Rick immediately went up a nearby stairwell as I remained on the lower deck. I could see him clearly cross the catwalk as he attempted to find the elusive shadow. As he crossed the catwalk, he could hear the footsteps ahead of him dissipate but was unable to locate anyone…or anything. We immediately went to locate security and found both officers on the pier below us.

CAT AND MOUSE

Later in the evening, this author was again in the Hangar Deck while Rick was examining the Engine Room. As I was walking through the area, I observed a shadow crossing ahead of me. The shadow stopped in a dimly lit area and stood as if it were watching me. I remained still and continued to observe the silhouette for about a minute as I debated

what to do next. I decided to walk at a normal pace past the figure, and as I did, it moved into the shadows and disappeared. I continued on past the area and sat down on a bench near the entrance to the Charleston Naval Shipyard Museum. As I sat there, I continued to hear noises from the direction of the shadow. After a few minutes, I again saw motion and went back to where I had seen the figure. Again, there was nothing there.

At that point, I decided to give it a few minutes, and I went into the Shipyard Museum. I spent a few minutes there deciding where to set up motion sensors, and after determining the best area I again exited back on to the Hangar Deck. As I walked toward where I had seen the figure, a shadow crossed directly in front of me and blocked the light. A second shadow did likewise. As I looked toward the light, I could distinctly see two figures near the snack bar area. As I approached, one slowly disappeared from sight and the second stepped back into the shadows and disappeared. I continued back down to that area and found no one, although I am positive the silhouette figures were human…at least in size and shape.

Once again, I am not ready to rubber stamp this experience or the previous one as a "ghostly" encounter, but what I experienced was not normal and still has me scratching my head wondering what exactly did occur.

RICK AND THE CAPTAIN

When we first arrived, Rick and I had spoken with Justin Davis, the security supervisor that evening, and asked him about his experiences. He informed us of what he referred to as an "urban legend." He stated that on the bridge, there is a wooden mat near the wheel of the ship. He states that if a person stands and spins the wheel and acts as if he is the captain, that person will feel a stern hand upon his shoulder. The grip is alleged to be that of the actual ship's captain who is strongly urging you to vacate his post.

Of course we had to try it.

Later that evening, I attempted my turn at the procedure and had no issues. Rick then took his turn. As he did so, he issued orders, spoke of

incoming kamikazes and directed all persons to "battle stations." I asked if he could parallel park the ship while he was at it.

We both joked about the legend and the fact that the captain was not too concerned with us. Rick spoke aloud and asked to speak with the captain. He asked if the captain had anything he wanted to tell us. Rick laughed at the silence, and as he turned, his Go-Pro Camera, which he had attached to his hat, began beeping and shut off. I checked his camera and observed that his freshly charged battery was now dead. I attempted to turn on the camera three times with no success. As Rick removed the camera, it turned on while facing him and snapped his picture. We both laughed at the incident and admitted that perhaps the captain was trying to contact Rick.

Rick then made the statement that the captain was going to have to do better than that.

Sometime later, Rick and I had split up. While I was playing cat-and-mouse on the Hangar Deck, Rick was in the Engine Room. As he

The bridge of the USS *Yorktown*. *Courtesy of KOP.*

The pamphlets and the telephone handset located by Rick Presnell. *Courtesy of Rick Presnell.*

looked around, he had an overwhelming feeling that he should check around the engines and see what may be around, in or under them. As he did so, he noticed a pile of old pamphlets, and he reached in and removed them. The Patriots Point pamphlets he found were over twenty years old and actually contained information on the USCGC *Comanche* that was scuttled in the nineties.

The pamphlets were interesting enough, but what was even more interesting was what they had been concealing. Behind the pamphlets was a handset and cord to a telephone. What is even more interesting is that the mouthpiece and earpiece were brass and different from any other phone we had seen on the ship. As Rick relayed his story and turned the phone over to security he speculated that perhaps the phone and its unique brass fittings were property of the captain and perhaps this was his way of saying that the next time Rick should use the proper channels when he wants to address him.

III.

THE HERITAGE

PATRIOTISM, PRIDE, PRESERVATION AND PATRIOTS POINT

PATRIOTS POINT

On March 29, 1973, South Carolina governor John C. West approved legislation creating the Patriots Point Development Authority. Part of the provisions of that legislation was to provide a place of education and recreation to "foster pride and patriotism in the United States, and to establish and develop a National Naval Museum of ships, naval and maritime equipment, artifacts, books, art, and other historical materials to tell the story of the importance of sea power."

Since Patriots Point opened, many ships have come and gone, but the USS *Yorktown* has always remained. She was acquired in 1974 and was opened to the public on January 3, 1976. She has always been the focal point of Patriots Point. In 1981, she was joined by the highly decorated World War II destroyer USS *Laffey* (DD-724). The two had served together as part of Task Force 58 in February 1945, when they participated in strikes on the Japanese homeland. The USS *Clamagore* (SS-343) also joined these two ships in 1981.

In addition to these ships, Patriots Point also is home to many other exhibits, including the Cold War Submarine Memorial, a Vietnam Support Base and the Medal of Honor Museum.

Since opening almost forty years ago, Patriots Point has exceeded expectations in preserving our military heritage and fulfilling its original goals. It also has certainly surpassed any expectations in regard to educating others about our military history and heritage. According to Patriots Point's Education Center, over twenty-two thousand scouts and students participate in overnight camping trips, and fifty thousand students visit Patriots Point annually. Their Education Center offers standard programs for kindergarten through twelfth grade and specialty programs for third, fifth and seventh grades.

In a recent interview regarding the educational experiences that a field trip to Patriots Point offers students, Barbara Hairfield, social studies coordinator for the Charleston County School District, stated, "Kids can read about World War II all day long in a textbook, and they'll remember some parts and not others, but they will remember those real world experiences. It's such a deeper learning experience for the kids, and we feel like that's really important."

To read about a legend is okay but to actually stand on the decks of a legend is...well, to quote a third-grade student, "That's awesome!"

THE USS *CLAMAGORE* (SS-342): THE LAST OF HER KIND

The USS *Clamagore* (SS-342) was commissioned in June 1945, a little too late to see action in World War II. She spent her thirty-year career operating out of Key West, New London and Charleston, South Carolina. She underwent several modifications, such as Guppy II and Guppy III, before the introduction of nuclear submarines phased out the diesel submarine. She is the only Guppy III submarine surviving as a museum ship.

"Guppy" stands for Greater Underwater Propulsion Power Program. This was initiated by the United States Navy after World War II in order to improve the speed, endurance and maneuverability of submarines.

The Heritage

Earlier in this book, "a gremlin in the freckle maker" was introduced. Although this particular paranormal entity was partial to diesel subs, I am sure there are similar creatures onboard every vessel in the United States Navy just waiting to initiate some young sailor. For the sake of this story told to me by my stepfather, we will focus on this particular creature and the havoc he wreaked on the unsuspecting sailor when he followed him into the freckle maker.

According to legend, gremlins are spirits similar to imps or poltergeists. Like the poltergeists, they have a knack for mischief. They are also mechanically inclined. Their sole purpose is to dismantle, dismember or destroy any piece of machinery that they can get their hands on.

Gremlins have been in existence ever since man created the first machine. It is a symbiotic existence that continues even to this date.

During World War I, gremlins began to make themselves known to pilots. This is why they are often associated with aeronautics and planes rather than ships. The spirits were originally believed to have had a great dislike for the British Royal Air Force and were accused of taking scissors to the wires and cables of biplanes.

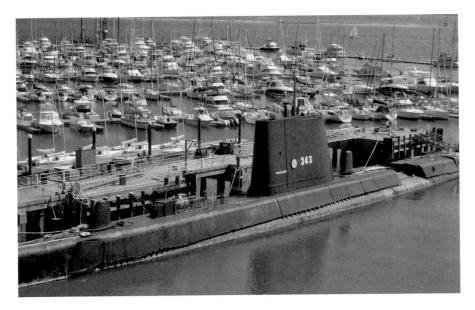

The USS *Clamagore* (SS-343). *Courtesy KOP.*

During World War II, the creatures stuck with the Royal Air Force (RAF). The continued to wreak havoc on the aircraft and were especially hard on the men of the high-altitude Photographic Reconnaissance Units (PRU) of the RAF. The creatures were responsible for otherwise inexplicable accidents that sometimes occurred during flights. Gremlins were also thought to, at one point, be a form of paranormal sabotage by the enemy. That train of thought soon proved untrue when the Luftwaffe of Germany began complaining of *kobolds*, mischievous spirits that attacked their aircraft.

Although the gremlins have long been associated with aircraft in modern times, their origins actually go back much further, to the German kobolds. The *Klabautermann* is a spirit from the beliefs of fishermen and sailors of Germany's north coast, the Netherlands and the Baltic Sea. The German belief in the Klabautermann dates back to at least the 1770s. According to these legends, Klabautermanns live on ships and are generally beneficial to the crew. The creatures are thought to be especially resourceful in times of danger and helpful in preventing the ship from sinking.

The Klabautermann's benevolent behavior lasts as long as the captain and his crew treat the creature courteously and respectfully. A Klabautermann will not leave its ship until it is on the verge of sinking with no chance of salvation. Because of this belief, superstitious sailors in the nineteenth century demanded that others pay the German gremlins respect. There are accounts that one captain actually created a place for his ship's gremlin in his cabin and offered the spirit the best food and drink on board. On the opposite end, there is an account of a crew that threw its captain overboard for denying the existence of the ship's Klabautermann. They are easily offended, and when they are angered, they turn to mischief. This may lead to the German gremlin revealing itself. If the gremlin reveals itself to a single sailor, that sailor will die, but if it reveals itself to an entire crew then the ship is doomed.

So gremlins have been associated with ships long before the airplane was even invented.

Often times, a gremlin will attach himself to a new and inexperienced sailor. This is because any mischief the spirit causes will inevitably

be blamed on the sailor and his ineptness. This is true for all vessels, including subs.

One of the favorite tricks of the gremlin is to follow the new sailor or submariner to the restroom. When duty calls, the spirit makes sure he is available.

The toilet, or head, aft of the torpedo room on a diesel sub such as the *Clamagore*, was one of their favorite places to lay in wait for a new shipmate. The reason was that this particular head was operated by an air expulsion valve. It was the only head operated in this manner. All shipmates were given instruction in the operation of this piece of machinery. It was a simple three-step process.

The gremlins would usually wait until an operation entitled "blowing sanitaries" was in effect. This was when the sub was pressurizing its septic system and expelling its waste at sea. All heads were marked with a sign marked "blowing sanitaries" in order to inform all personnel that the operation was in progress.

The gremlins would inevitably remove the sign from the head, aft of the torpedo room.

This was what gave this particular head the nickname the "freckle maker." More than once, a young sailor has been standing in that head and pulled the green handle while the vessel was blowing sanitaries. The result was a pressurized release of all materials in that line. The pressurized waste materials would inevitably result in the addition of moist brown freckles to the sailor's appearance…and also to the entire head.

But that was not the worst that could happen.

The gremlins were very much in control of removing the warning sign, but they could not control what action the sailor would take once inside the head. There was only one of two directions that the sailor could be guided by Mother Nature. The gremlins truly enjoyed a good standing performance but what they really desired and relished was a seated one.

The reason behind their pleasure in a seated performance was quite simple. It was a much greater pay-off for their hard work. A seated sailor made a seal upon the seat. When undersea, the blowing sanitaries

procedure took several hundred pounds of pressurized air. Although the buttocks-to-seat seal may contain the majority of freckles, it would often result in the unsuspecting sailor being launched—literally—from his perch at the pull of the big green handle.

A gremlin in the freckle maker was never a pleasant experience for the victim, but it sure entertained the victim's shipmates—and also the gremlin—whenever blowing sanitaries took place.

THE USS *LAFFEY* (DD-724): THE SHIP THAT WOULD NOT DIE

The USS *Laffey* (DD -724) was named after Medal of Honor recipient Seaman Bartlett Laffey. Bartlett Laffey, an Irishman by birth, enlisted in the United States Navy on March 17, 1862. On March 5, 1864, during the Civil War, Seaman Laffey was assigned to the gunboat USS *Marmora* when the Confederates launched a heavy attack on Union positions at Yazoo City, Mississippi.

In the midst of battle and under heavy enemy fire, Seaman Laffey landed a twelve-pound howitzer and her crew. Despite excessive enemy rifle fire, which cut up the howitzer's gun carriage and severed her rammer, Laffey never abandoned his post. He remained with his gun and thus contributed greatly to repelling the fierce Confederate assault. Seaman Laffey received the Medal of Honor for his actions.

In World War II, the USS *Laffey* would live up to her namesake, and in the heat of battle, she too would not abandon her position, despite a tremendous Japanese onslaught. On April 16, 1945, she was on radar picket station 1, about thirty miles north of Okinawa, Japan. That day she became the target of a massive airstrike of Japanese bombers and kamikazes. Although the USS *Laffey* shot down eleven of the attacking enemy aircraft, five kamikazes made direct strikes on the ship. Three bombs also struck her, and two others detonated close enough to her to inflict damage. Of her 336-man crew, 32 were killed and 71 were wounded.

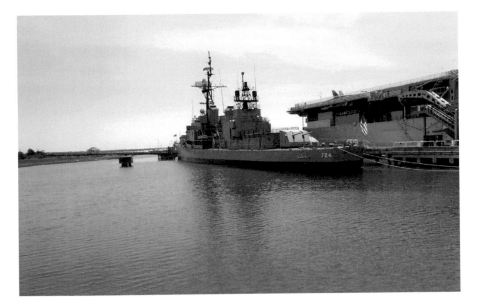

The USS *Laffey* (DD-724). *Courtesy of KOP.*

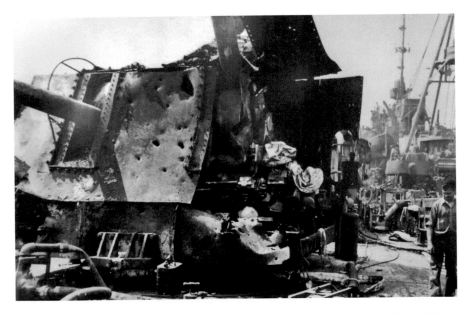

Battle damage to the USS *Laffey*, "The Ship That Would Not Die." *Courtesy of Patriots Point.*

In the midst of the battle, Captain F. Julian Becton was asked by the *Laffey*'s assistant communications officer if he thought they would have to abandon ship. Becton's response was a harsh, "No! I'll never abandon ship as long as a gun will fire." Although nearly crippled, the USS *Laffey*, like her namesake, never fled or abandoned her position, earning her the nickname "The Ship That Would Not Die."

THE MEDAL OF HONOR MUSEUM

In October 1993, the Medal of Honor Museum opened at Patriots Point on the USS *Yorktown*. The museum honors those who have received this country's highest military decoration. Since it was established in July 1862, during the Civil War, the requirements for such an honor have been:

> *Conspicuous gallantry and intrepidity at the risk of his or her life above and beyond the call of duty while engaged in an action against any enemy of the United States; while engaged in military operations involving conflict with an opposing foreign force; or while serving with friendly foreign forces engaged in an armed conflict against an opposing armed force in which the United States is not a belligerent party.*

The Medal of Honor Museum has quickly become one of the Charleston area's greatest attractions. It serves to remind all of us that freedom is not and never has been free. It teaches us the cost to obtain our freedom starting with the American Revolutionary War, and it also teaches us what the price continues to be to maintain it through the centuries, even through today's War on Terror. The price was paid by the sacrifices of our military personnel, their families and those patriotic American heroes, like Seaman Bartlett Laffey, honored here in this exhibit.

Our youth today are bombarded by the so-called idols and heroes of the sports and entertainment industry that teach them that self-indulgence and personal gain are the objectives of life. The Patriots Point Education Center and exhibits such as the Medal of Honor Museum show them

that there is a different type of hero, one who strives to serve a higher calling for a larger goal at the price of self-sacrifice. It teaches them the meaning of valor and that valor knows no age limit.

As a young student, it is awe-inspiring to know that a true hero was a thirteen-year-old drummer in the Civil War who refused to lay down his drum and inspired his troop onward, or that the most decorated hero in World War II received all his awards for acts that he committed all before he turned twenty-one.

During World War II, Audie Murphy became this country's most decorated soldier when he distinguished himself "above and beyond the call of duty" by personally destroying six tanks, in addition to killing over 240 German soldiers and wounding and capturing many others. He received U.S. military decorations that not only included the Medal of Honor but also the Distinguished Service Cross, two

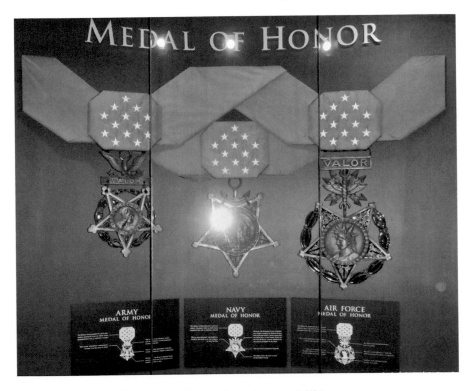

The Medal of Honor Museum at Patriots Point. *Courtesy of KOP.*

Silver Stars, the Legion of Merit, two Bronze Stars with Valor and three Purple Hearts. Murphy participated in campaigns in North Africa, Sicily, Italy, France and Germany, as denoted by his European-African-Middle Eastern Campaign Medal with one silver battle star (denoting five campaigns), four bronze battle stars, plus a bronze arrowhead representing his two amphibious assault landings at Sicily and southern France. During the French Campaign, Murphy was awarded two Presidential Citations.

The French government also awarded Murphy its Chevalier of the Legion of Honor. He also received two *Croix de guerre* medals from France and the *Croix de guerre 1940 Palm* from Belgium. Murphy was also awarded the Combat Infantryman Badge.

And he accomplished all this before he turned twenty-one.

Perhaps among the students that tour the USS *Yorktown* there is a future recipient of the Medal of Honor whose actions were inspired by what was learned on a school field trip.

CONCLUSION

According to Patriots Point records, 141 men lost their lives while serving on the USS *Yorktown*. Many have had experiences that lead them to believe that perhaps some of the personnel continue to serve onboard the ship or engage in battles long past. If that is true then it truly speaks of the dedication, determination and commitment that those individuals possessed, a dedication that spans eternity.

The claims of paranormal experiences onboard the USS *Yorktown* have been around ever since she arrived at Patriots Point. The incidents that have occurred in the presence of staff and visitors alike have been collected here and presented to you, the reader, to accept or dismiss. Whether you choose to believe in the paranormal aspect of the USS *Yorktown* or feel that perhaps this is a case of another author "blowing sanitaries" and sending a lot of pressurized fecal material your way, you must admit that the history behind the hauntings must be preserved for future generations to experience, enjoy and learn from.

Case in point:

This is the fourth book I have had the privilege of working on with my youngest daughter as photographer. Our visit together to the USS *Yorktown* stands out far above any of the other experiences we have shared on any of the other projects. Quite fittingly, the aircraft carrier

Photographer Kayla Orr in helicopter over the USS *Yorktown* at Patriots Point. *Courtesy of author.*

will now always be the site of her first flight as we photographed the Fighting Lady from a helicopter high above her. It is a moment we shared and will never forget.

As we explored the enormous vessel together, we interacted with each other over every exhibit as we traversed the decks with history uniting us. The ship not only served as a bridge to where my generation and hers could meet in the middle, but it also served as a time machine that transported us back to when my father served our country and it gave me an opportunity to speak to her about the grandfather she barely knew. My father lied about being eighteen in order to get into the United States Navy at the end of World War II and ended up on diesel subs. A lot has changed since 1945 and 2012 when my eighteen-year-old daughter—his granddaughter—photographed the last Guppy III diesel sub in existence from the deck of the Yorktown at Patriots Point. Even though sixty-seven years stood between those two eighteen-year-old teenagers, I saw my old

man's ghost when I looked in my daughter's eyes that day. The vast sea of time was crossed in one afternoon, and three generations were united by the phantoms of Patriots Point and the ghosts of the USS *Yorktown*.

BIBLIOGRAPHY

Bostick, Douglas. *USS Yorktown (CV-10): The History of the "Fighting Lady."* Charleston, SC. Charleston Postcard Company, 2010.

Braesch, Lieutenant Connie, and Lieutenant Junior Grade Ryan White. "Coast Guard Heroes: Charles Walter David Jr." *COAST GUARD Compass—Official Blog of the US Coast Guard.* November 3, 2010. http://coastguard.dodlive.mil/2010/11/coast-guard-heroes-charles-walter-david-jr/. (accessed May 25, 2012).

Buxton, Geordie and Macy, Ed. *Haunted Harbor: Charleston's Maritime Ghosts and the Unexplained.* Charleston, SC: The History Press, 2005

The Coast Guard at War V: Transports and Escorts. Part I [Escorts]. Washington, D.C.: U.S. Coast Guard, March 1, 1949.

Courrege, Diette. "Museum Brings Lessons to Life." (Charleston, SC) *Post and Courier.* June 8, 2011.

Ewing, Steve. *Patriots Point: In Remembrance.* Missoula, MT: Published for Patriots Point Development Authority by Pictorial Histories Publishing Company, 1999.

Fontenoy, Paul E. *Weapons and Warfare: Aircraft Carriers.* Santa Barbara, CA: ABC-CLIO Inc., 2006.

Ghost Hunters. "Haunted by Heroes," season 8, episode 10. Produced by Pilgrim Films and Television for the Sy-Fy Channel.

Hawes, Jason, and Grant Wilson, with Michael J. Friedman. *Ghost Hunting: True Stories of Unexplained Phenomena from the Atlantic Paranormal Society.* New York: Pocket Books: A Division of Simon and Schuster, 2007.

Hinkle, David Randall, ed. *Naval Submarine League: United States Submarines.* Waterford, CT: Hugh Lauter Levin Associates, Inc. and Sonalysts, Inc. 2002.

Kell, Crystal. "Another Sighting of Shadow Ed—Ghost on USS Yorktown!!!" *USS Yorktown Sailor: Veterans Forum.* December 8, 2008. http://www.yorktownsailor.com/yorktown/indexYS.htm. (accessed June 18, 2012).

Ketchum, Richard M. *Victory at Yorktown: The Campaign that Won the Revolution.* New York: Henry Holt and Company Publishers LLC, 2004.

Kitchens, Reuben P., Jr. *Pacific Carrier: Saga of the USS Yorktown CV-10 in WWII.* Mt. Pleasant, SC: The Nautical and Aviation Publishing Company of America, 2002.

Kropf, Schuyler. "Plan to Sink Comanche Under Fire." (Charleston, SC) *News and Courier.* December 6, 1991

"The New Coast Guard Cutters." *Marine Engineering and Shipping Review* 40 (1935).

Ragan, Mark K. *The Hunley.* Orangeburg, SC: Sandlapper Publishing Company, 2005.

Rentz, Mark. *Megalodon: Hunting the Hunter.* Lehigh Acres, FL: Paleo Press, 2002.

"The Saga of the Four Chaplains." *The Four Chaplains Memorial Foundation.* http://www.fourchaplains.org/story.html (accessed May 25, 2012).

Scheina, Robert. *U.S. Coast Guard Cutters & Craft of World War II.* Annapolis, MD: Naval Institute Press, 1982.

Schuster, John. Haunting Museums: The Strange and Uncanny Stories Behind the Most Mysterious Exhibits. New York: Tom Dogherty Associates, LLC, 2009.

Silkie, Savannah. "Forum: The USS Yorktown." *Project: Paranormal.* http://projectparanormal.org/forum/5978/the-uss-yorktown/ (accessed June 22, 2012).

TAPS: The Atlantic Paranormal Society homepage. http://www.the-atlantic-paranormal-society.com/ (accessed June 22, 2012).

Wikipedia, The Free Encyclopedia. "Echo (phenomenon)." http://en.wikipedia. org/w/index.php?title=Echo_(phenomenon)&oldid=496299031 (accessed June 19, 2012).

———. "Four Chaplains." http://en.wikipedia.org/w/index. php?title=Four_Chaplains&oldid=486698720 (accessed May 25, 2012).

———. "Ghost Hunters." http://en.wikipedia.org/w/index. php?title=Ghost_Hunters&oldid=497266618 (accessed June 22, 2012).

———. "Gremlin." http://en.wikipedia.org/w/index.php?title=Greml in&oldid=491124710 (accessed May 24, 2012).

———. "Kobold." http://en.wikipedia.org/w/index.php?title=Kobold &oldid=493470358 (accessed May 25, 2012).

———. "Megalodon." http://en.wikipedia.org/w/index.php?title=Me galodon&oldid=492610550 (accessed June 11, 2012).

———. "Siege of Yorktown." http://en.wikipedia.org/w/index. php?title=Siege_of_Yorktown&oldid=499124620 (accessed June 26, 2012).

———. "USCGC *Comanche* (WPG-76)." http://en.wikipedia.org/w/ index.php?title=USCGC_Comanche_(WPG-76)&oldid=473636353 (accessed June 6, 2012).

———. "USS *Asheville* (PG-21)." http://en.wikipedia.org/w/index. php?title=USS_Asheville_(PG-21)&oldid=444531599 (accessed June 18, 2012).

———. "USS *Yorktown* (1839)." http://en.wikipedia.org/w/index. php?title=USS_Yorktown_(1839)&oldid=495310531 (accessed June 26, 2012).

———. "USS *Yorktown* (CG-48)." http://en.wikipedia.org/w/index. php?title=USS_Yorktown_(CG-48)&oldid=455880475 (accessed June 26, 2012).

———. "USS *Yorktown* (CV-5)." http://en.wikipedia.org/w/index. php?title=USS_Yorktown_(CV-5)&oldid=498129483 (accessed June 26, 2012).

———. "USS *Yorktown* (CV-10)." http://en.wikipedia.org/w/index. php?title=USS_Yorktown_(CV-10)&oldid=496622198 (accessed June 27, 2012).

————. "USS *Yorktown* (PG-1)." http://en.wikipedia.org/w/index. php?title=USS_Yorktown_(PG-1)&oldid=492028402 (accessed June 26, 2012).

Williamsburg Tours. "Let the Adventure Begin: The Haunted and Historical Moore House at Yorktown Battlefield." http://www. williamsburgtours.com/archives/925 (accessed July 1, 2012).

Wise, Warren L. "SyFy's 'Ghost Hunters' Explores Paranormal Side of Yorktown." (Charleston, SC) *Post and Courier*. May 2, 2012.

About the Author

Bruce Orr was raised in the Lowcountry of South Carolina and grew up hunting and fishing the plantations of Berkeley County with his father and brothers. It was during those times that he spent many evenings listening to the tales and legends surrounding this historic area. As he grew into an adult, this natural curiosity in seeking the facts brought him into law enforcement, where he eventually became a detective and a supervisor within his agency's Criminal Investigative Division. Now retired, he uses the skills he obtained in his career to research the legends and lore that he grew up with. After his first book in 2010, he developed a company called Lost in Legend in order to research, record and preserve the folklore and legends of the South Carolina Lowcountry, and the history behind them, for future generations.

ABOUT THE PHOTOGRAPHER

 Kayla Orr is the staff photographer for Lost in Legend. She became interested in photography at a very young age. She studied photography through her high school curriculum and, at the age of sixteen, created KOP Shots, her own amateur photography company.

Two years later, she has become a professional photographer and has been involved in many projects, including, with The History Press, imagery for four books and covers for two of them.

Visit us at

www.historypress.net